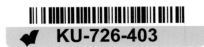
WALTER SICKERT
AND THE CAMDEN TOWN GROUP

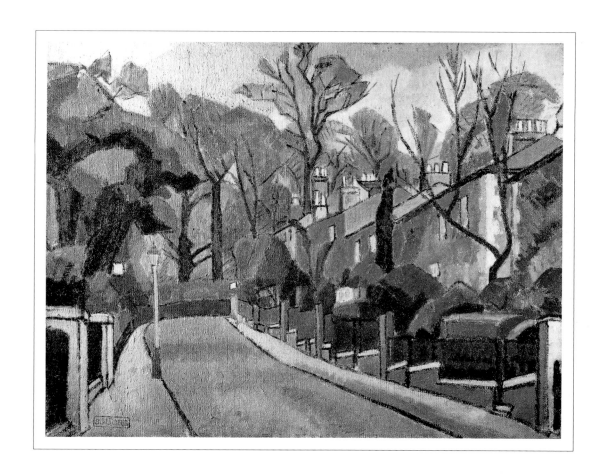

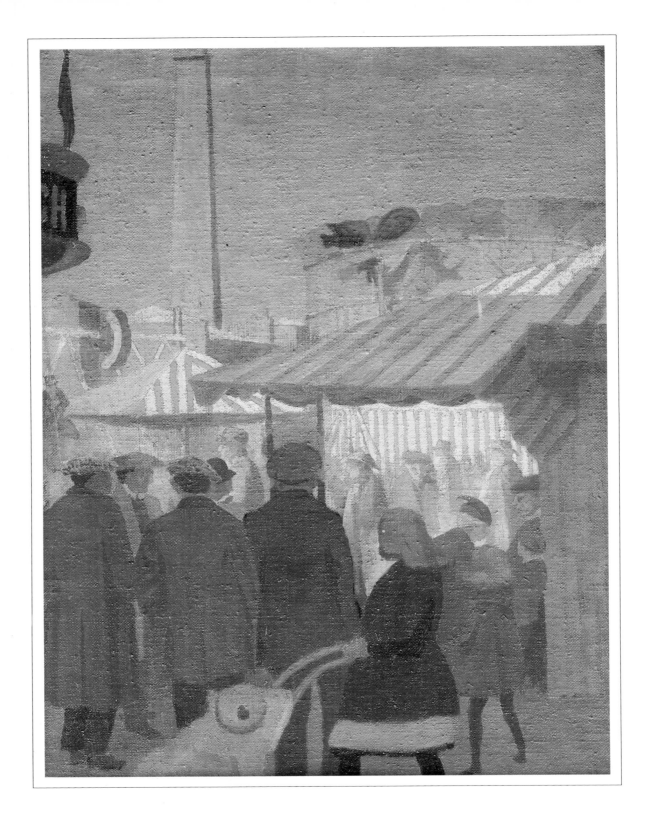

WALTER SICKERT
AND THE CAMDEN TOWN GROUP

MAUREEN CONNETT

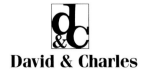

David & Charles

*This book is dedicated
to Maurice Feild (1905–1988),
painter and teacher. Without him,
it would not have been written.*

Jacket illustrations: Front: Walter Sickert,
The Dogana and the Santa Maria della Salute, Venice (1896) Oil on
canvas, 29 × 26in (74 × 65.4cm), private collection. (Back,
clockwise from top left) Charles Ginner, *The Angel, Islington* (1914)
Oil on canvas, 27 × 20in (69 × 51cm), private collection. Spencer
Gore, *Mornington Crescent* (c. 1911) Oil on canvas, 20 × 24in
(51 × 61cm), British Council. Malcolm Drummond, *19 Fitzroy
Street* (c. 1913–14) Oil on canvas, 28 × 20in (71 × 51cm), Laing
Art Gallery & Museum, Newcastle-upon-Tyne. Robert Bevan,
The Cab Yard, St John's Wood, Evening (c. 1910) Oil on canvas,
25 × 30in (63 × 76cm), private collection.

Preliminary illustrations: (Page 1) Spencer Gore, *Cambrian
Road, Richmond* (1913/14) Oil on canvas, 16 × 20in
(41 × 51cm), Tate Gallery. (Page 2) Malcolm Drummond,
The Fairground (c. 1920) Oil on canvas, 24 × 18in
(61 × 45cm), private collection. (Page 3) Walter Sickert, *Inez on
the Zattere* (n.d.) Oil on panel, 16 × 11¾in (41 × 30cm), private
collection.

A DAVID & CHARLES BOOK

Copyright © Maureen Connett 1992

First published 1992

British Library Cataloguing in Publication Data
A catalogue record for this book is available from the British
Library.

ISBN 0 7153 9997 7

Book designed by Michael Head
Typeset by ICON, Exeter
and printed in Italy by OFSA SpA
for David & Charles
Brunel House Newton Abbot Devon.

CONTENTS

FOREWORD

The Camden Town Group can be seen as a collection of very various talents presided over by the powerful personality of Sickert; and if we think of a typical Camden Town canvas – the generally smallish size: the urban, not to say seedy, subject matter; the solid paint, low-keyed but fresh and full of inventive colour – it is likely to be a Sickert that comes to mind. However, a great variety of painters were associated with the group at one time or another: Augustus John, Wyndham Lewis, Lucien Pissarro have little to do with the 'typical' Camden Town painting described above; and to some, Gilman and Spencer Gore are at least as important in the Group's short flowering as Sickert himself.

I am always surprised that such a vigorous, tough and very English school is not better known in its own country – and what could be more English, for all their admiration of Degas and Gauguin, than an eating-house by Gilman, an interior by Sickert, or a leafy square by Gore? However, there was a bad period a year or so ago when it seemed as if not a single Camden Town painting could be found on public display in the whole of London. I remember an American visitor, an admirer of Sickert, baffled by what he saw, correctly, as this neglect of one of our finest painters.

When I started to teach in the fifties, the influence of Camden Town was strong in many art schools. At Camberwell, students drew sight-size – a Sickertian imperative – and squared up their studies, of drab streets or pub interiors, on to their canvases. All this was swept away, together with the teaching of life drawing or perspective, in the sixties, of course; and interest in the Camden Town period waned.

It has increased in recent years. There have been two extensive exhibitions at Christie's and the Fine Art Society, a Gilman show, and Wendy Baron's important books. But it can seem as if we haven't still fully recognised the lasting importance in the history of English art of the Camden Town painters. So it is a great pleasure to welcome an addition to our knowledge of the group. Maureen Connett brings forward these rich and varied characters like actors on a stage, with a great relish for their individualities and the parts they play in this comparatively short-lived, but immensely productive and sharply flavoured period.

Bernard Dunstan RA

PREFACE

The beauty of Spencer Gore's colour in the Anthony d'Offay show of 1983 was a revelation to me. At this time, I was fortunate enough to be a member of Maurice Feild's painting group which met every Wednesday in St Albans. As well as being an exceptional teacher, Maurice enjoyed talking about art and artists. So I took the Gore catalogue into the studio the following Wednesday to hear his views. I was astonished to learn how little known was Gore's work. He has been neglected like the other members of the Camden Town Group. Yet their importance is beyond question and some of our most distinguished contemporary painters have been deeply influenced by Sickert and Gilman, in particular. Members of the general public have hardly heard their names.

My aim in writing this book has been to introduce the general reader to these interesting and diverse English painters in the hope that he or she will want to see the pictures for themselves. In trying to work out the relationship between the lives and the talents of these individuals, I hope I have been writing about the human spirit and the artistic impulse.

My debt to the scholarship of Dr Wendy Baron and others is obvious and I have listed those books which I have found most helpful. Marjorie Lilly's brilliant account of Sickert and his circle has been indispensable. I would like to thank all those friends and colleagues whose expertise and support have sustained me. In particular, I am grateful to Bernard Dunstan for writing the foreword, Keith Searle who read the manuscript, and Brenda Greysmith, editor of *Traditional Homes.*

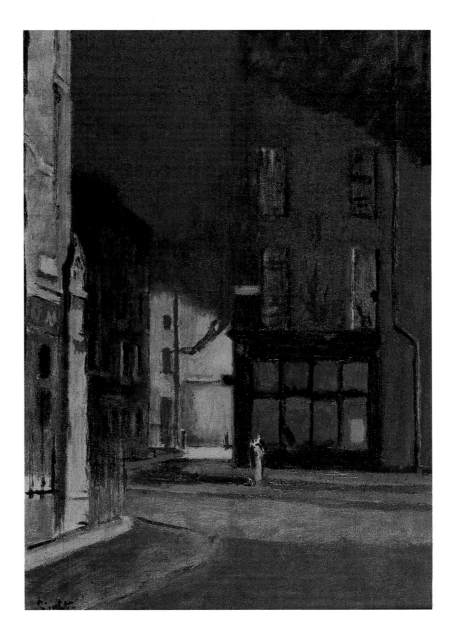

Walter Sickert, *The Corner of Maple Street* (1898)
Oil on canvas, 30 × 20in (75 × 50cm). Private collection.

INTRODUCTION

The Camden Town Group came about naturally and because there was a need for it. A number of talented, like-minded painters had gathered in Fitzroy Street, North London. Their leader was Walter Sickert, an immensely gifted and widely experienced artist. His familiarity with the leading French Impressionists, such as Edgar Degas, gave him authority and when he returned to London in 1905, after nearly seven years abroad, he was sought after as a guide and mentor. His studio in Fitzroy Street became a magnet and painters, collectors, students and members of the public flocked to his Saturday afternoon 'At Homes'.

Sickert and his circle drew their inspiration from the everyday life around them in the dingy streets and lodging-houses of Camden Town. Their models were often working men and women seen in their ordinary domestic settings. Their typical subjects also included pubs, railway stations, landscapes, theatre scenes, shop fronts and informal portraits of themselves and each other. Sickert was a born teacher as well as an inspired painter and he announced his intention 'to finish the education' of the most promising painters of the day. In addition he wanted to create a milieu where the general public could get used to seeing painting of a modern character. With his guidance, the Fitzroy Street Group operated as a commercial co-operative. Each member paid a share of the rent and contributed an easel on which the work was displayed.

The Saturday afternoon 'At Homes' were friendly and successful. Tea and slab cake were served and painters and visitors enjoyed meeting each other and discussing the paintings. It was unpretentious work; small, room-sized pictures on sale at modest prices were appreciated by a faithful clientele which included several famous collectors, such as Sir Hugh Lane.

The Fitzroy Street Group developed into the Camden Town Group. The 'At Homes' had given confidence and support to the emerging painters. They became friends and wanted to exhibit together publicly and on a more ambitious scale. In the spring of 1911, over a convivial dinner at Gatti's restaurant, Sickert, Robert Bevan, Charles Ginner, Spencer Gore and Harold Gilman decided to create a new society. Sickert called it the Camden Town Group because he declared in his usual extravagant way that the district had 'been so watered with his tears' that 'something important must sooner or later spring from its soil'.

The founder members of the Camden Town Group were Walter Bayes, Robert Bevan, Harold Gilman, Charles Ginner, Spencer Gore, Lucien Pissarro, James Bolivar Manson and Walter Sickert. They wanted to establish themselves as a serious society and invited those painters whom they considered to be the best and most influential of the day to

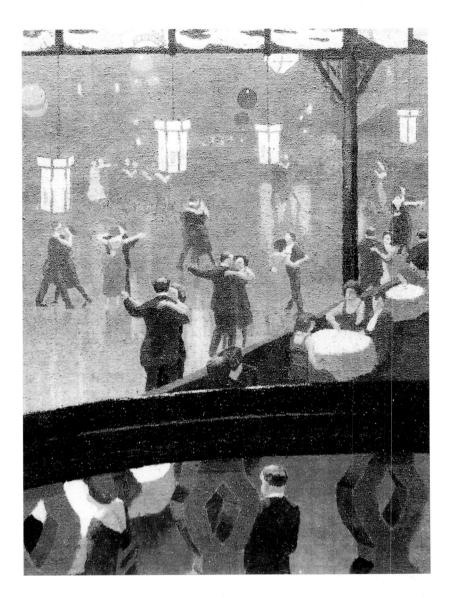

Malcolm Drummond, *Hammersmith Palais de Danse* (1920)
Oil on canvas, 26 × 25in (66 × 65cm). Plymouth City Museum and Art Gallery.

8

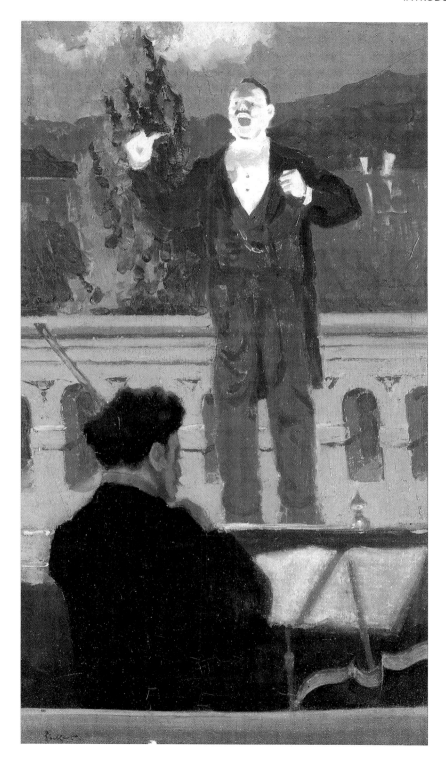

join them. They fixed the Group's number at sixteen. Invited members were Drummond, Innes, Augustus John, Lamb, Lewis, Lightfoot, Ratcliffe and Doman Turner who was Gore's pupil. Duncan Grant was elected to replace Lightfoot who died in September 1911. Women were excluded out of professional jealousy and to keep out Sickert's numerous lady friends. This narrow-mindedness was actually against their own interests; for one of Sickert's friends, Ethel Sands, was not only a talented painter but also a wealthy society hostess who could easily have found the Group a bevy of rich patrons. As it was, the three exhibitions held during 1911 and 1912 were not a financial success though their artistic merit was recognised.

The first exhibition was in June 1911 and each member was entitled to show a maximum of four works. In all, fifty-five pictures were shown and the subjects ranged from urban and rural landscapes to Camden Town figures in interiors, cab-yard scenes by Bevan, music-halls by Gore and figure compositions by Sickert which he named the Camden Town Murder, probably to attract publicity. Two further exhibitions followed, in December 1911 and December 1912. All were held at the Carfax Gallery in Bury Street, St James's. Although the shows made no money for the owner, Arthur Clifton, who was a friend and patron, the painters themselves were well pleased because their work had been seen and appreciated.

As individual painters matured and found their own style and direction, the Camden Town Group began to break up and did not survive the premature death in 1914 of its President, Spencer Gore. It had served its purpose and given support and self-confidence to a number of talented artists at a crucial time in their careers.

The Construction of the Book
The 'leading role' in the Camden Town Group was played by Walter Sickert, and he dominated the stage. The 'principal players' were those painters who gave and received most from the Group. The 'rest of the company' played minor parts in the action played out in North London from about 1905 to 1914, an exciting time in the development of English painting.

Walter Sickert, *The Lion Comique* (1887)
Oil on canvas, 19 × 12in (48 × 31cm). Private collection.

SICKERT: A PERSONAL SKETCH

Sickert fascinated everyone, including himself. He was cosmopolitan, witty, highly intelligent, startlingly handsome and a chameleon in his changing moods and appearances. The key to his personality lay in his love of the theatre and his passion for painting. Often playing a role, needing an audience to bring out his enchantment, he was essentially the solitary artist. As such, he knew instinctively what he needed for his development. His relationships with people and places were formed to serve his art – and they did so.

'The Canaletto of Dieppe', Sickert also painted Venice and the Paris music-hall before coming into his own as the Master of the Camden Town Group. In each place, he found a woman to look after him. Seemingly so independent, Sickert was lost without female companionship and support. Over his eighty-two years he had three wives, many mistresses and several women friends to whom he wrote affectionate letters. They responded to his gaiety, charm, good looks and bewitching companionship. The price of all this was high. Sickert would brook no challenge. When a woman came under his influence, she would end up either putting her own work a poor second, like Sylvia Gosse who took over the donkey-work of running his school at Rowlandson House, or turning out pale copies of his style. This happened with his third wife, Thérèse Lessore. Before she married him, she used to paint strange little interiors, with a fleeting, fey quality, very much her own. Sickert's overpowering personality swamped her and she began instead to echo his subjects. Then she became exclusively interested in him and when he became ill and old, she devoted herself entirely to his welfare.

Sickert's wives were all women of intelligence, refinement and distinction. Ellen Cobden, daughter of the politician Richard Cobden, was a fashionable society hostess with a circle of influential friends. Self-confident, independent and twelve years older, she at first resisted his advances but after a long courtship, they married in 1885. Her secure financial position, and the distinguished people with whom she associated, were of great benefit to Sickert. She was able to help him with portrait commissions, and was appreciative of his unique talents. She had a literary bent and wrote a novel, *Wistons*, under the pseudonym Miles Amber. The hero of it was, of course, Sickert himself. Ellen supported his career as a painter with her heart and soul, and provided financial as well as emotional backing. But she got tired of his wandering ways. He would vanish for several weeks, and then turn up suddenly as if he had never been away and he was brazenly and continually unfaithful. After a fourteen-year marriage, she divorced him in 1899. He was so distressed that he left the country.

Sickert's attitude to his own infidelities is curious. He was either unable or unwilling to see their effect on Ellen. It may have been detachment or indifference, but his refusal to mend his ways comes out in this exchange of letters of December 1898, just before the final break:

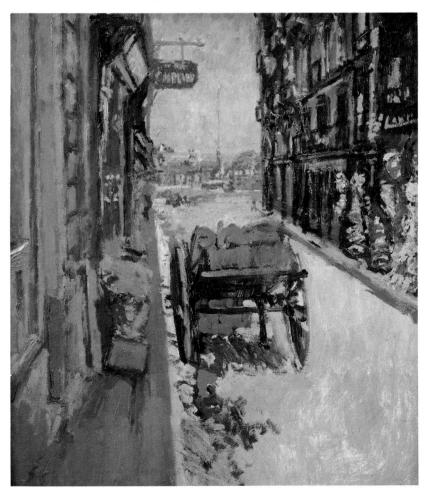

Walter Sickert, *The Hand Cart, Dieppe* (n.d.)
Oil on Canvas, 24 × 19½in (81 × 49cm).

(Opposite)
Walter Sickert, *Ennui* (c.1917/18)
Oil on canvas, 30 × 22in (76 × 56cm). Ashmolean Museum, Oxford.

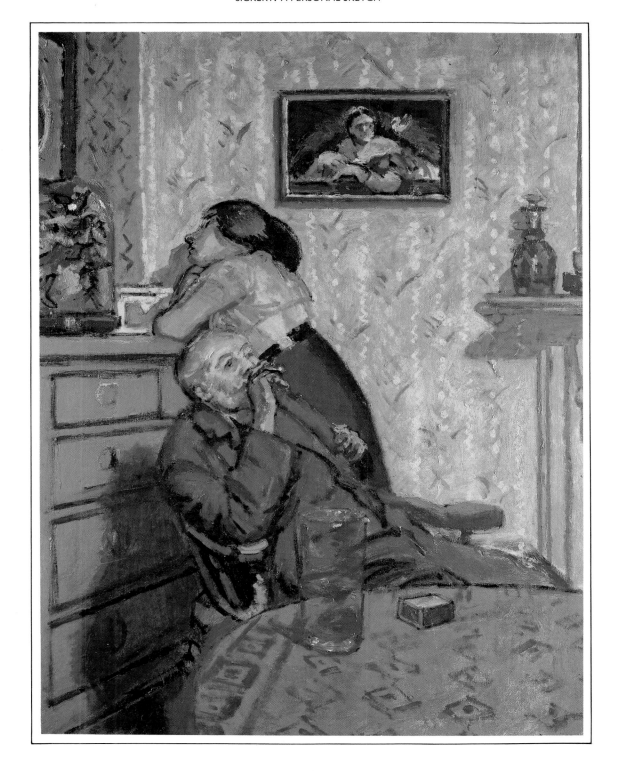

Dear Walter,

In spite of your having told me, when we parted in Switzerland in September 1896, that immediately after our marriage and ever since you have lived an adulterous life and that you felt sure you could never live a different one, I have been hoping against hope that you could abandon it but all I have heard of you during the last two years has forced me to give up all possible hope for the future.
Yours truly,
E.M. Sickert

To this sad and resigned letter, Sickert replied:

My dear Nellie,
I have received your letter of December 8. It is quite true that I have not been faithful to you since our marriage, & it is equally true that during the two years since we parted I have been intimate with several women. I have chosen my mode of life, & I am unable to alter it. An undertaking on my part would be misleading.
Ever your profoundly attached
Walter Sickert (Sutton 1976: 91)

Christine Angus, his second wife, married Sickert in 1911. At the time of their marriage she was already weak, and this was intensified as a result of consumption. Illness had intensified her self-control also. However weary she might be, her stiff poise never relaxed. She was always perfectly arranged, every fold of her dress in place, her abundant plaits neatly braided. Sickert was enchanted by her appearance, especially her deep blue, slanting eyes, and was immensely proud of her skilful, highly professional embroidery.

Sickert's courtship of Christine was conducted at top speed and with alarming extravagance. Perhaps he was still in a state of shock, for he had just been jilted at the Camden Town Register Office. The girl had decided at the last moment that she preferred not to marry him. Within a month, he became enamoured of Christine, who was the daughter of a well-off Scottish merchant. He pursued her with express letters and telegrams at two-hourly intervals, which began to wear Christine down. Every evening he would go to the house to kiss the doorstep. This eccentricity did not endear him to Mr Angus, who thought Sickert was after his daughter's money. Christine's determination to go ahead with the marriage carried the day, however and the ceremony took place at Paddington Register Office on 29 July. Spencer Gore was the best man.

They had nine years of great happiness. Christine was the perfect foil for Sickert, being undemanding, quiet and steadfast. His Scottish wife summed up all that he admired in his favourite race; intellect, sanity, independence. Her delicacy gave her a poignant appeal but Sickert did not face up to its consequences and left her to deal with the harsh austerities of London in wartime with his usual insouciance.

Christine's death at the age of 44 devastated Sickert. They had returned to France after the war and were living in Envermeu, a small and rather desolate village, some fifteen kilometres from Dieppe. where they had acquired a house, the Villa d'Aumale. The winter of 1919-20 was bitterly cold and Sickert, happily painting out of doors, left Christine to cope alone in the chilly house. She had become increasingly frail and the exertions of superintending alone the removal from London to France combined with the cruel cold proved fatal.

Bizarre and theatrical though it was, Sickert's mourning was profound. Once he knew she was dying, he completely shaved his head, his face became ashen white and he dressed in a black velvet coat as if to enhance the ghastly effect of his appearance. As Christine lay on her deathbed, her husband was downstairs entertaining his in-laws. Fully equal to the tragic occasion, he became as usual, the perfect host, telling endless anecdotes and even singing his favourite little tunes.

The next day Christine died and Sickert made a dramatic performance of the occasion. When Mr Angus and his younger daughter went into the room to see the body, they were astounded at what they saw. Two workmen wearing blue blouses and berets and smoking cigarettes were in the room. 'One was sitting on the bed and the other was mixing some clay on a table. They had come to make a death mask.'

The bereaved husband acted strangely at the funeral. Dressed in tweeds and looking terribly nervous, Sickert walked slowly to the ceremony, supported by the Anglican priest in Dieppe. A hold-up in the proceedings occurred, for the hearse, which came with Christine's ashes from Rouen, was terribly late in arriving. Sickert waited by the railings of the graveyard and,

As soon as the casket which was used in place of a funerary urn was carried past him, he took it, opened it, pressed it against his breast and bent his head. Then with a large gesture he plunged his hands into the casket and instead of throwing the ashes into the grave he tossed them into the air. A gust of wind scattered them over the witnesses of this sinister scene, they covered us with a fine white dust or floated away like snow against the blue sky.

(Sutton 1976: 199)

This scene has a strange echo of the burial of Ophelia in *Hamlet*. Was Sickert actually capable of true feeling? Or was the world a stage to him, with all the men and women merely players and himself in the leading role?

Thérèse Lessore was a very different character from Christine. His third wife was an artist too, and Sickert had the pleasure of discussing his work with her. She was a godsend to him in his lonely years of widowhood. When he returned from Dieppe in 1922 she went with him night after night to music-halls, where they both made drawings. They had been friends for several years and he had admired her pictures and

her appearance, which he described as being 'like a Persian miniature.' When she was still married to the painter, Bernard Adeney, he used to invite them both to Fitzroy Street. Then they left Hampstead to move into Number 20 and Thérèse gave dignified parties in the candle-lit rooms. Sickert had always attended these with great eagerness.

She and Bernard Adeney had drifted apart. He married again and Thérèse buried herself in her work. She painted incessantly through this difficult period, just as Sickert attempted to do after the death of Christine; they had a great deal in common. In 1926 they married.

Sickert was by now in his mid-60s, his restlessness curbed by bodily fatigue and his painting erratic. He was far more dependent on Thérèse than on his first wives. Sickert and Thérèse's minds ran along similar paths, and he loved to talk painting with her; he respected her opinions and her formidable fund of information about painters. She had a touch of asperity which he relished, and she would sum up a situation with severe little comments. The perfect listener, she had the rare gift of drawing people out, and everyone was conscious of her bright intelligence and intense interest. Small and frail with a childish figure, she had a smooth, olive face, very white teeth and a mass of black, curly hair. She wore Liberty-style clothes which she made herself in a straight pinafore style, white stockings and little black dancing sandals. When she left the house, which was seldom, she would wrap herself in a long black cloak.

An individualist, then. But after she married Sickert, her fey quality began to disappear. Her fleeting charm and acute if small talent began to be swamped by his personality. When he became ill, she was devotion itself. During his final years they lived outside Bath where Thérèse bore the strains of a sick husband, wartime restrictions and very little money. She nursed him through a succession of strokes and watched patiently over his wanderings. The old restlessness had taken hold of him again and he would disappear into the city, to be brought back by kindly cab drivers. As Sickert became more and more helpless and confused, Thérèse had to cope with an impossible patient. Having had complete freedom all his life, he was outraged to find himself in the hands of nurses who were obliged to impose restrictions on him.

Another source of bewilderment was the presence of evacuees from Balham who were billeted on them. He was mystified to come across these strangers walking about his house; his memory had to be constantly refreshed about them. Sometimes he would plead to be taken back to Fitzroy Street. And until his final collapse, he thought he was still teaching.

Thérèse was loyalty itself and would never admit, even to herself, that his painting and teaching days were over. Every morning he would start off gaily to the old barn in the gardens to 'take his class'.

> When I went after him, I would find him waiting for the students who never came. I tried to cheer him with promises that they would be there next day, and take his mind off the subject by talking of something else. He seemed contented for the time being but next day he always went back to the barn to look for them again.
> (Lilly 1971 : 171)

Such was the private life of the great painter. In public, his last years had many interesting moments. He was the Grand Old Man of English art and enjoyed the role. Various friends came to see him. They regarded the spacious and airy St George's Hill House at Bathampton as a worthy setting. William and Alice Rothenstein turned up for his seventy-ninth birthday. Sickert was dressed in bright orange clothes, a coloured neckerchief and a Dieppe sailor's peaked cap cocked over one eye. Over the celebratory meal, he reminisced about the theatre, his own early work and talked brilliantly of Whistler and Degas. Cecil Beaton visited him in September 1940 and thought that, despite the onset of senility, his existence was idyllic. He was living in the past of his youth and saw everything in terms of pictures that he had already painted or would paint.

How was he personally regarded by those who were intimately acquainted with him but did not entirely succumb to his charm? Jacques-Emil Blanche, the French painter and a close friend, said that Sickert had a heart of stone. John Rothenstein believed that one of the mainsprings of his actions was a love of change; of change simply for its own sake. Throughout his life he would abruptly sever relationships with old friends and companions. He would delight in varying the character in which he appeared to the world; from dandy to fisherman or gamekeeper to chef. He dressed and played each part to perfection. The extraordinary power and fascination of his personality enabled him to have his own way in everything. The creative spirit worked strongly in him and nothing was allowed to come between him and the exercise of his great gifts as an artist.

Bibliography
Lilly, Marjorie, 1971. *Sickert, The Painter and his Circle*. London, Elek Books Limited.
Sutton, Denys, 1976. *Walter Sickert*. London, Michael Joseph.

WALTER SICKERT:
A BORN CHAMELEON

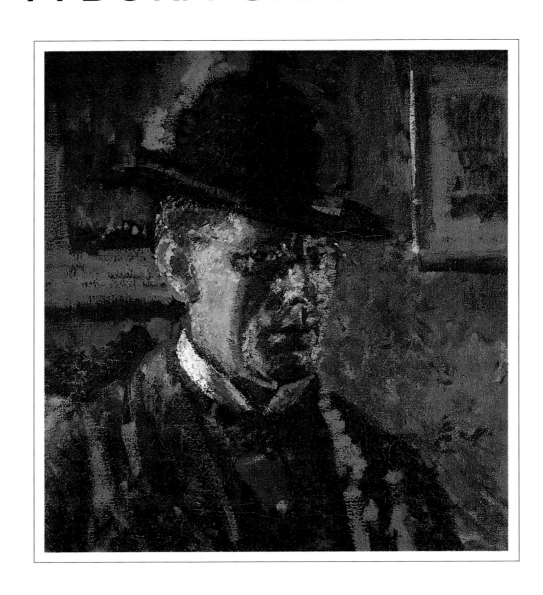

THE PUPIL OF WHISTLER

The Butterfly

Whistler, Sickert's first teacher, was witty, charming, a dandy, intensely theatrical and self-centred, a compelling and compulsive talker and rather a snob. A cosmopolitan, he was the leader of advanced art, a shrewd manipulator and ruthless in getting what he wanted. He was quick to see that he had a disciple in Sickert and persuaded him to abandon his studies at the Slade School. Walter was already disaffected and Whistler commented: 'You've wasted your money, Walter; there's no use in wasting your time, too.'

Sickert became Whistler's assistant, turning up daily at the studio in Tite Street, preparing canvases and helping to print the Master's Venetian etchings. They went on memorising expeditions together, especially at night. Whistler would scrutinise the subject at great length, perhaps a view of the Thames by moonlight. He would then turn his back on the scene and describe its main features for Sickert to check against a list. The next morning Whistler would produce a Nocturne, with Sickert working alongside him.

Sickert was expected to 'fag' for the fastidious Butterfly, doing the tedious jobs that are part of the apprentice's lot. For example, on a painting trip to St Ives in 1883 Walter went on ahead and organised the lodgings. They put up at a small house kept by an old lady. A prodigious worker, Whistler was up early and expected his pupil to do the same. There was no question of taking it easy when he was around. He would scream, 'Have you got my panels prepared? Did you mix that grey paint and put it in a tube? Why aren't you all up? Walter, you are in a condition of drivel.'

Sickert's personality began to exert itself over the several months that they stayed in St Ives. By now he was a young man of twenty-three, startlingly handsome and engaging with a strong independent streak. He was biding his time, learning what he could from Whistler, but always with an unerring instinct for his own work. He became friendly with the St Ives fishermen, wearing a jersey and top-boots as they did and winning their hearts with his bonhomie. The fishermen enjoyed his company and made him presents of fish which he would then hand over to the landlady. She was charmed but Whistler was not. No one else was allowed to receive attention; he took the view that he was the one who should be given such presents. He was intensely irritated, too, when Sickert went off by himself, painting five or six pictures a day and talking to the fishermen as he worked.

(Opposite)
Walter Sickert, *The Juvenile Lead, Self-Portrait* (1907/8)
Oil on canvas, 20 × 18in (51 × 46cm). Southampton Art Gallery.

Whistler taught only by example. He neither suggested subjects nor examined his pupils' work. Sickert listened and watched and took what he needed for his own development. One piece of advice he jotted down on his cuff:

The Secret of Drawing:

The artist should seize on the chief point of interest and draw it in elaborately, then expand from it outwards; in this way the picture would be a perfect thing from start to finish and be complete, 'even if one were to be arrested in the middle of it.'

Some Whistlerian characteristics are: delicacy and restriction of tone and the use of low tones against a dark background; thin, slippery paint; gentle modelling and extreme simplification of both figure and background; lack of clarity and definition. All this adds up to a new sensibility; where suggestion, mood and atmosphere act on the observer; where beauty of tone in particular affects the senses rather as it does in music. With this refinement went a thorough professionalism and an

Walter Sickert, *Royal Hotel, Dieppe* (c. 1874)
Oil on canvas, 20 × 24in (51 × 61cm). Private collection.

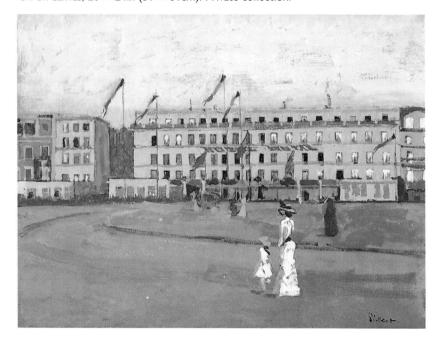

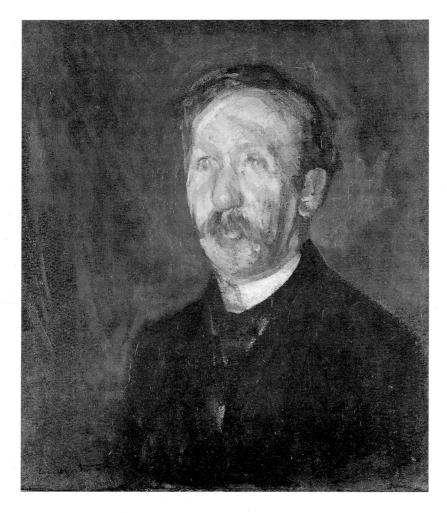

Walter Sickert, *George Moore* (c. 1891)
Oil on canvas, 24 × 20in (60 × 50cm). Tate Gallery.

conscious stages, each so planned as to form a steady progression to a foreseen end'.

It was the thin quality, the slightness of form and content which was the basis of his later criticism of Whistler. However, he never lost his admiration for the Butterfly's little panels, especially the seascapes. He called them 'masterpieces of classic painting' and praised the 'extraordinary beauty and truth of the relative colours'. In these small pictures he felt that Whistler had expressed the essence of his talent:

> Never was instrument better understood and more fully exploited than Whistler has understood and exploited oil-paint in these panels. He has solved in them a problem that has hitherto seemed insoluble: to give a result of deliberateness to a work done in a few hours from nature.

Sickert learned his craft from a master of it. He served a sort of apprenticeship from 1882-5, picking up the art of etching and acquiring the technique of subtle, low-toned application and a fastidious approach to the materials. Gradually, Sickert moved out of Whistler's orbit but he had much to thank him for – not least his introduction to the great Edgar Degas who became the 'lighthouse' of his existence. In May 1883, Whistler asked Sickert to take his celebrated *Portrait of The Artist's Mother* to Paris for inclusion in the Salon. Because Whistler had given him a letter of introduction, he was invited to Degas' studio in the Rue Fontaine Saint-Georges. A fluent French speaker, Sickert made the most of his opportunity; he saw marvellous pictures in the modern style, very different from Whistler's. Not only did he hold his own with Degas, who was a formidable character, but the two men became friends. The distinguished middle-aged artist took a great liking to this young and confident Englishman. As for Sickert, he immediately recognised his new mentor and revered Degas for the rest of his life. How exciting for him to get to know the great man; he remembered every word of their conversations and was influenced by them at every subsequent stage of his development.

Degas and the French Tradition; Marriage to Ellen Cobden
Degas was for Sickert the perfect master, being the most intellectual and traditional French painter of his generation. He met him at just the right time, when he needed to move on. From Degas, he received reinforcement for his own inclination which was to build up work of lasting importance of which the sketches and the studies are a significant part. They agreed on the importance of drawing, and of painting away from nature.

As a spiritual mentor Degas influenced Sickert's character rather more than his vision. The insistence of the older man on hard work, a strict routine and the highest standards of discipline and technical skill made the deepest impression on the mercurial Sickert. His scorn of fashion and

emphasis on drawing. Whistler's etchings are very fine and show the quality of his sharp, nervous drawing to perfection.

Sickert was bowled over by Whistler's talent at first, and declared that he was the only painter alive who had 'immense genius'. He insisted on the excellence and importance of Whistler's work and was profoundly influenced by him in etching – both in subject matter and technique – and especially in his move towards simplification. As time went on, and Sickert became experienced enough to judge for himself, he began to re-evaluate Whistler as an artist and to find him wanting. The fact that Whistler painted *alla prima* (that is 'in one wet'), rather than in deliberately developed stages, was a limitation. Sickert felt that such paintings were not 'begun, continued and ended. Brought about by

his relentless devotion to an ideal were an inspiration and the two painters met on 'terms of affectionate intimacy'. 'This truly great man' believed in Sickert's abilities and expected much of him and Sickert's devotion to Degas was deep and lasting.

Sickert wrote a personal account of Degas shortly after the death of the great French painter in September 1917. What emerges is Sickert's reverence for his way of life; the fact that his days were dedicated to the practice of his art and that nothing was allowed to get in the way:

> Degas had the good-nature and the high spirits that attend a sense of great power exercised in the proper channel and therefore profoundly satisfied... There was his work and when his eyes were tired, there was conversation, there were endless rambles through the streets of Paris and long rides in and on omnibuses.

Degas had trouble with his eyes and it was a 'torment' to draw for much of the time. His affliction led him to use pastel which allowed him to work on a larger scale. Sickert went on:

> When we consider the immense output of the later half of his career, the high intellectual value of it, and the generous store of beauty that forms its contribution to the history of art, the debonair heroism of such a life, its inspired adaptation to conditions apparently intolerable, must remain a monument for amazement and respect.

He had the good fortune to live in a land of painters and in a city where art was esteemed: 'Paris was well aware of Degas and surrounded him with the profoundest veneration, fear and affection.'

A penetrating remark that Sickert made about Matisse, 'The great artist is humbler and a shade clumsier', sums up concisely the reason why the 'pupil of Whistler' became the 'follower of Degas'. The great master had the simple heart and the large vision that belongs to genius and Sickert recognised this.

Sickert's early meetings with Degas came at the time when he was courting his first wife. Ellen Cobden is a shadowy figure. 'Pretty, absurdly pretty' according to Sickert, who also commented on her beautiful hair. She had a strong character which he admired: 'She used to scold me sometimes. And went very pink when she was angry ... a sort of carnation ... charming. I had to fetch my palette and state the tone ...' She had much to be angry about. As a husband, Sickert was a failure. Ellen married Sickert in 1885 and they were divorced in 1899.

Ellen Cobden was clever, well-off and a fashionable hostess with a large circle of friends. Sickert met her through his sister, Helena, and he

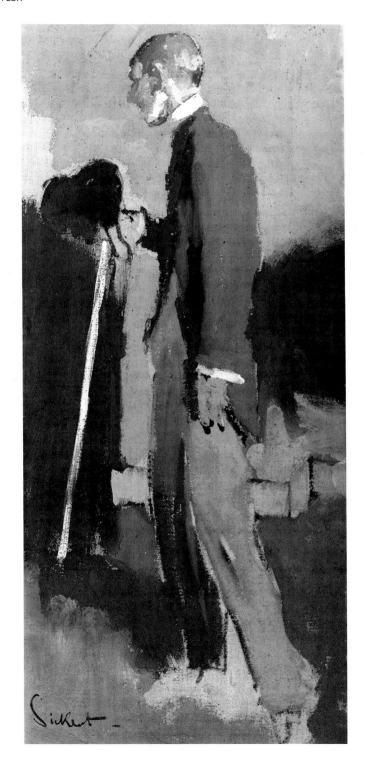

Walter Sickert, *Aubrey Beardsley* (1894)
Oil on canvas, 30 × 12in (76 × 31cm). Tate Gallery.

would invite this whole crowd of intelligent women to tea at his lodgings in Claremont Square, off the Pentonville Road in Islington. Twelve years older, well established and of a cooler temperament, Nellie was not inclined to accept him at first, but Sickert was in love, and she finally consented. Her prosperous circumstances helped him to become an artist. She gave him every kind of support and things went well at first. They married on 10 June and spent the honeymoon abroad, visiting, among other places, Vienna, Milan and Munich. Ellen was fully aware of the importance of his gifts but must have felt slighted when he went off to draw and etch at this most intimate of times.

Marriage was never allowed to interfere with his work in any way. He would even absent himself from a dinner-party in his own home to attend the music-halls when he was involved in a particular study. He liked to go his own way and his practice of having his studios away from home allowed him to entertain his women friends and to conduct his liaisons at leisure. He would disappear for weeks at a time, then turn up without any explanation. Despite the fact that they were intellectually well matched and allowed each other a great deal of freedom, things became impossible. Ellen left the house when he began to bring his mistresses home. A year later, in 1899, she was granted a divorce. Distressed and worried about money, Sickert decided to leave England. The separation depressed him and the usual source of comfort was not available – his close friend, Florence Pash who had always stood by him in hard times, married in 1898. In the autumn of that year, Sickert decided to move to Dieppe and there followed one of the most rewarding periods of his life.

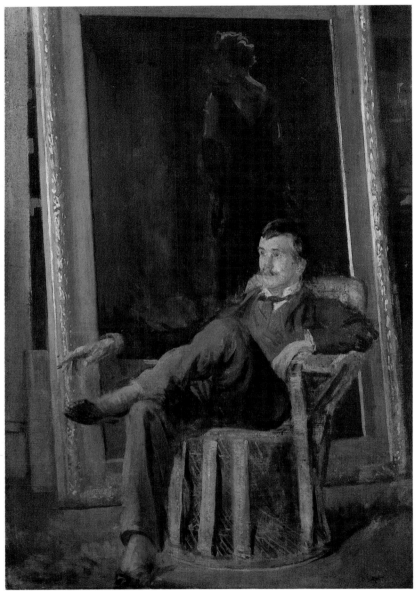

Walter Sickert, *Philip Wilson Steer* (c. 1895)
Oil on canvas, 85½ × 23½in (216 × 60cm). National Portrait Gallery.

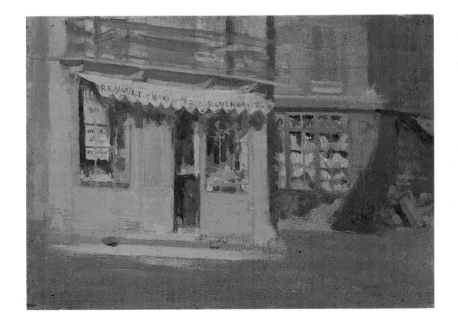

Walter Sickert, *The Red Shop* (c. 1888)
Oil on canvas, 10½ × 14in (27 × 36cm). Norwich Castle Museum.

THE CANALETTO OF DIEPPE

After his move to France, Sickert alternated between Dieppe and Venice for the next six years. Dieppe inspired some of Sickert's finest pictures. He painted its waterfronts, streets, old houses, crooked corners, shop fronts, crumbling architecture, shabby buildings and ordinary people. His approach was free and direct because he knew and understood his subject and the landscape suited his own vision. The ancient church of St Jacques was a motif which attracted him again and again and he depicted its façade in moonlight and sunlight and on gloomy and grey days. The age, character and rough and ready working atmosphere of the quayside appealed to him; he wrote that he was 'working his goldmine – Dieppe'.

It was a second home to him. He had spent many childhood holidays in this fashionable coastal spa, it was his parents' favourite place and he and Ellen had passed the summer there after their European honeymoon tour. So when he became depressed by the separation from Ellen and the scandal and strain of 'this loathsome divorce' became intolerable, he fled to Dieppe. He put up first at 1 rue de l'Hotel de Ville. The brisk sea air revived him and he swam daily. Another woman entered his life.

She was Augustine Eugénie Villain, known as Titine. She was a fishwife with a stall on the quayside. Tall, statuesque with 'flaming Venetian hair and milky freckled skin', she was spontaneous and earthy with a gift for repartee. Sought after as a model during the summer months, it is not surprising that she met Sickert and sat for him. Once his divorce was finalised in 1899 and there was no danger of Titine being involved in the proceedings, Sickert left his seedy room in the town and moved in with her and her children. At least one of these – a boy – was Sickert's and they all settled into a house in Neuville. It had a garden with a room for him to paint in. It was called the Maison Villain – Sickert had it printed on his writing-paper and for a while he was happy in this new role. He helped Titine on the fish-stall, and supplied food and wine.

He painted daily and was sanguine about the difficulties of working out of doors. Contact with London was vital to him; he missed the stimulus but kept in close touch with his artist friends. To one he writes:

> Your letter was most welcome, caught me at a moment when I had rushed from an outdoor sitting not only indoors but into bed in the only hope of thawing again. The papers are like rain on a thirsty land. I hanker after the cackle of my own town & kind, though I am very happy & well here. Such constant sun and daylight. Not only do I take coffee with *la belle rousse* but that angel in divine shape permits me to share the table of her children at cost price, gives me the use of her bonne, employs a seamstress … to sew me strange shirts after my own designs …

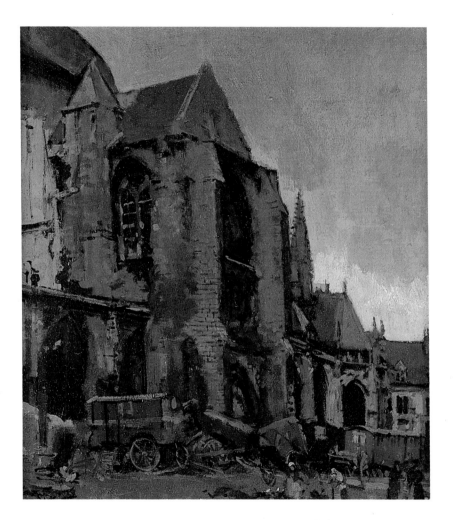

Walter Sickert, *Gipsy Caravan in front of St Jacques, Dieppe* (1898)
Oil on canvas, 22 × 18in (56 × 46cm). Private collection.

His friends were not told the truth about his relationship. Sickert was probably anxious that his mother and sister not hear about the affair.

His liaison with Titine made no difference to his social position. Low life was fine, up to a point, but Sickert also relished high life. There was a large English colony who welcomed him and an international set made up of writers, painters, sculptors and collectors. Sickert's charm and accomplishments made him a success everywhere. As a fluent speaker, he

mixed freely in the sophisticated French milieu at the heart of which was the eminent Blanche family.

Jacques-Emil Blanche was an important figure in Sickert's life because he did so much to help him. He bought vast quantities of Sickerts and presented them to galleries and collections. Through Blanche, Sickert met important clients (for instance, André Gide), who bought his work, he was admitted to French painting societies and he met the influential Paris dealer Durand-Ruel. At one time, Blanche got him a teaching post in Paris, supervising once a week at the school where he taught.

'Blanchie', as he was called, was a talented artist who painted such notable characters as Proust, Henry James, Diaghilev and Jean Cocteau. A discerning collector, he knew the Impressionists and it was through the Blanches that Sickert gradually became better acquainted with the great Degas. Blanchie's mother's house at Dieppe, the Chalet du Bas Fort Blanc on the seafront, was a meeting place for the rich, the talented and the fashionable. Summer visitors, such as George Moore, Monet, Pissarro, Gide, Beardsley and Degas met in the drawing-room. When life with Titine and the children seemed rather too spartan, Sickert made a flying visit to the Blanches' home in Paris and luxuriated in the comfort of regular meals, and trips to galleries. His 'polished angel' was unfailingly kind and generous. In later life, Sickert was lukewarm about him as about other old friends. It was Blanche who characterised him as 'the Canaletto of Dieppe.'

Mixing freely as an individual, Sickert was able to make close friendships with cultured women whose sympathy he craved. An example of this need comes in a letter he wrote in his most charming vein to Alice, wife of the English painter, Will Rothenstein: 'I can't tell you how your letter soothed and consoled me. There is something about female consolation of quite extraordinary efficacy. It seems round & soft somehow. I can't describe it. But it touches the spot, softly and caressingly. I can do with some more at any time when you have any to spare ...'

Another friend, Florence Pash, came in useful when he decided to give up his London studio in Robert Street. She had the chore of supervising the removal and sending on the drawings and panels he wished to keep.

A romance may have existed between Sickert and Mrs Price whose husband was in South Africa with the Post Office Rifles. She gave him some of her husband's clothes and they went to Paris together on two occasions with a party. Phyllis, her daughter, was immune to the Sickert charm and out of loyalty to her father, perhaps, made herself disagreeable to him. She declared him to be wicked. Piqued, he pressed her for a reason and she hit on the idea that nobody with such beautiful wavy hair could possibly be good. He took his 'neat revenge'. The next day, he appeared at the luncheon table completely bald; all his golden hair had been completely shaved off. The little girl screamed the house down.

It seems that Sickert was not fond of children, especially if they interfered with his pleasure. His neglect of his son Maurice amounted to abandonment. When the boy was eleven, Sickert asked his friends the McEvoys to look after him until the next day; he cried all night. In fact, his father left him there for six months. Maurice later fought in the First World War and lost an eye. He was decorated with the Croix de Guerre and Sickert painted him in uniform. During his recuperation from his wound, he was looked after by the McEvoys at Abbots Leigh, Freshford. Later, he became desperately lonely and dissipated. Sickert never mentioned him. The role of father did not appeal to him, perhaps. Sickert moved out of Titine's house prior to the summer of 1902; their affair was presumably over.

Walter Sickert, *The Bathers, Dieppe* (c. 1902/3)
Oil on canvas, 51½ × 40in (131 × 104cm). Walker Art Gallery Liverpool.

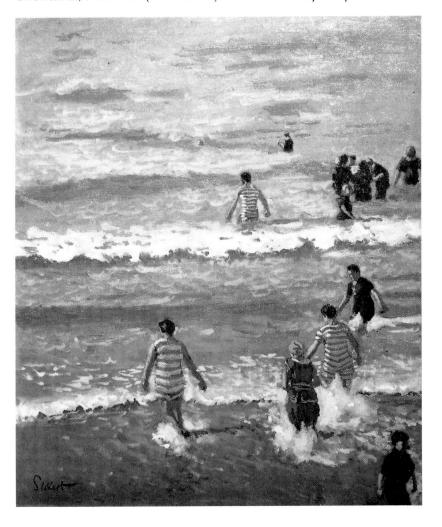

VENICE: SOPHISTICATION AND SQUALOR

Theatrical and mysterious, dramatic and claustrophobic, glittering and sombre – Venice was a stage with ever-shifting scenes. There was the squalid and depraved and also the cultivated and sophisticated – Sickert enjoyed every scene and was a leading player whenever he chose. It presented him with a unique challenge: generations of artists had worked in this queen of cities, including Whistler. Could Sickert make something new of its ravishing sights?

He first went to Venice in 1895 and may have stayed a year. At this time, his marriage to Ellen Cobden was breaking down and although he was distressed about the impending scandal of divorce, nothing would induce him to mend his ways. There is a note of self-dramatising in his claim that, 'The tension of suspense is awful to me, for what I know she must be undergoing. I have really forgotten myself in the contemplation of the sufferings I have inflicted on that unhappy woman.'

The beauty of the city stimulated his interest in landscape painting and he made numerous studies and drawings of St Mark's, both the façade and the interior. He was seeking the 'character' of each scene and his chief interest was in the handling of paint. The interior of St Mark's intrigued him; he conveys the mysterious shadows in the aisles, the play of light on stone, the gleam of gold on the central crucifix. Other architectural subjects he painted during subsequent visits were San Barnaba and Santa Maria Formosa, the Bridge of Sighs, the Doge's Palace and the Campanile, and Santa Maria della Salute. Even when the scene is pure architecture, there is still a feeling of waiting, a sense that the action may begin at any time, that the players are ready in the wings.

Sickert regarded painting as his trade and knew that he had to be productive to live. 'Without bulk no commercial painter can be made', he said and his output was prolific and intense. By 1903, he had achieved a position in French art circles where both his Dieppe and Venetian pictures were admired. Until 1909, he was more or less a member of the School of Paris. In February of that year, for instance, he was one of six artists who exhibited in a show at Durand-Ruel's. He was represented by fifteen pictures, mainly Venetian and Dieppe scenes and a Bedford music-hall. Sickert was always an individual artist who did not fit easily into any category. Blanche praised his 'sure method, fine artistic conscience and grave vision. His education is purely classical; his vision quite modern'. Blanche thought that Sickert possessed 'a charming artist's nature, refined and conscientious'. Sickert met Bonnard, Vuillard, Maurice Denis and Signac and was always on the fringes of modernism, yet never absorbed into a clique or fashionable movement.

From 1899 to 1904 Sickert travelled between the sea ports of Dieppe and Venice, and made frequent trips to Paris, painting incessantly and reporting that he was 'dog-tired at night'. Sickert and Venice were made for each other and he knew that he was developing rapidly and finding himself as an original artist. As always, he meditated at length on the nature and practice of painting, experimenting constantly and seeking for the ideal handling. He acknowledged in a letter what he had learnt from Philip Wilson Steer. To Steer, probably with regard to the interior of St Mark's he wrote:

> For all practical purposes the more experience I have, the more I find that the only things that seem to me to have a direct bearing on the practical purpose of painting my pictures are the things that I have learnt from you. To see the thing all at once. To work open

Walter Sickert, *The Lion of St Mark* (n.d.)
Oil on canvas, 35½ × 35in (90 × 89cm). Fitzwilliam Museum, Cambridge.

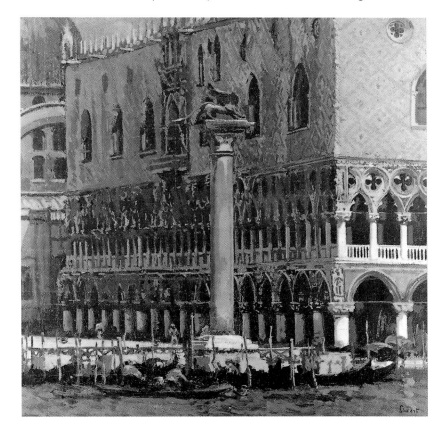

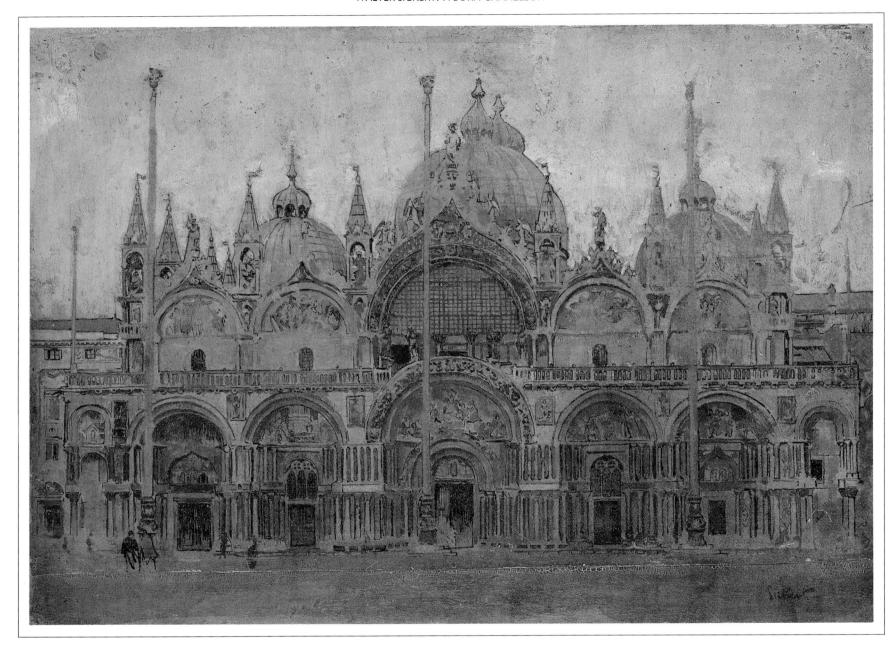

Walter Sickert, *The Façade of St Mark's* (1895)
Oil on canvas, 9 × 12in (22 × 31cm). Ashmolean Museum, Oxford.

and loose, freely with a full brush and full colour. And to understand that, when, with that full colour, the drawing has been got, the picture is done.

Socially, too, Sickert was in his element. Venice was one of the cosmopolitan centres of Europe, attracting pleasure-seekers and artists, and it was then growing in prosperity. Living was relatively cheap, even palaces were not expensive to rent and life for the middle classes was comfortable, with excellent servants easily obtained. Many artists, composers and writers lived in or around the Grand Canal in luxurious and glamorous surroundings. A fascinating and interesting circle of people welcomed him, including the English residents. Surprisingly, he would attend the English Church of St George's in Campo S Vio and even take the collection plate round.

Sickert was popular with everyone, including such distinguished people as Lady Radnor, a discerning connoisseur of music; the Curtises, friends of Henry James and Sargent, who were installed in the Palazzo Barbaro; and Baron Giorgio Franchetti who was a wealthy dilettante: he bought the Ca'd'Oro and restored it in perfect taste and at considerable expense. The Baron would play the piano and harpsichord for Sickert and cook him superb dinners for the pleasure of arguing about Venetian painting with him.

Elegant drawing-rooms, operas, concerts and plays with great visiting stars at the Fenice Theatre all appealed to Sickert. He was especially keen on the rich humour of Goldoni and continued to read and quote from his favourite play, *Le Baroffè Chiozzote*, long after leaving Venice. His love of low life and enjoyment of local bars and restaurants emerged strongly for the first time while he was in Venice. He found the ordinary people intriguing and picturesque. The poverty, sensuality and sinister atmosphere of the back alleys excited him. He explored the lagoons and the islands and even set up a makeshift studio on one of the most deserted inlets.

Low life attracted him and he mixed with the prostitutes who sat for him. He came into his own as a figure painter, with the ability to convey both the subtlety of the female nude and the relationship between figure and setting. He got his 'splendid models' who posed 'like angels' from the Giorgione, a lively trattoria run by a Signor de Rossi. La Giuseppina was his favourite model. Her bunched-up hair, sharp features and haunted expression delighted him. She brought her mother and close friends to his room at 940 Calle dei Frati. He would paint the same models over and over again, in the same poses, on a floral couch with a draped, beribboned washstand as a prop. He was called 'the master of the night table' because of these paintings, which were strong meat for an English audience. The women are shown as weary and worn-out as well as coquettish. Sometimes he includes a self-portrait, in one picture, he shows himself as dissolute and knowing with La Guiseppina hunched in a mood of wretchedness behind him. A portrait of her aged mother is

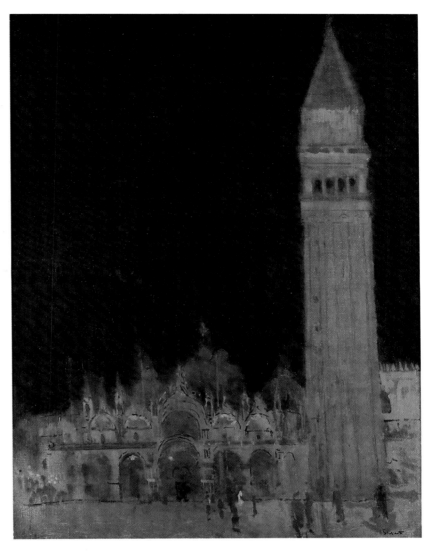

Walter Sickert, *Campanile, Venice*(1896-7)
Oil on canvas, 31 × 24in (76 × 60cm). Private collection.

still shocking; her despair and absolute poverty are conveyed with stark truth. Sickert's detachment gives such pictures their strength.

Such a way of life had its alarms and he got into a panic thinking he had caught a venereal disease. To a male friend he wrote that there was no possibility of catching 'anything so sporting in Dieppe' but that he had given himself 'the chance once or twice' in Venice. He confessed to being 'irritable to a pitch of madness, nervous, apprehensive' and suffering 'agonies of fear'. It turned out to be a false alarm. Delaine, the chief surgeon of the Dieppe hospital, told him that he had gout.

To his cultured women friends, he presented a very different face. Two of his closest friends were William Stokes Hulton and his wife, Constanza. Hulton was an occasional writer and amateur painter who even gave Sickert lessons in 1904. Mrs Hulton was a charming and warm-hearted woman with just that sort of feminine sympathy that Sickert longed for. He captured her elegance in delightful drawings, introduced her to his sophisticated friends and kept up an affectionate correspondence with her.

Both Dieppe and Venice were spiritual states as well as actual places for him. They had an interior reality which comes only with knowledge and familiarity. He wrote to Mrs Hulton: 'When I was in Venice, I was under the impression that I lived in Dieppe, and had *gone* to Venice, and now I feel as if I lived in Venice, and had *gone* to Dieppe.'

In his own opinion, he created more effectively when not in front of the motif. He had achieved his goal which was to be able to work up a subject from memory and from drawings, so that a painting was 'a song learned by heart'. It was his practice to paint some of his Venetian pictures in Dieppe and some of his Dieppe landscapes in Venice.

Venice intensified his gifts. He was able to express the many sides of his complex personality and move freely in both high and low society. Such a contrast can be seen in his work. The Venetian landscapes are strikingly expressive of the cultivated man of taste: a cloudless sky like a backdrop; an unpeopled square like an empty stage – such canvases are theatrical in effect. There is occasionally a breathless quality where you feel the presence of the artist and his utmost concentration on the scene. The colour is refined with dramatic compositions conveying mood and atmosphere. In his figure painting he developed the themes for which he was to become best known and so influential: one or two figures in an intimate setting.

Walter Sickert, *Mamma Mia Poveretta* (1903/4)
Oil on canvas, 18 × 15in (46 × 38cm). Manchester City Art Galleries.

CHAPTER FOUR
THE MASTER OF CAMDEN TOWN

Sickert's return to London in 1905 was vitally important both for his own development and for the inspiration he gave to a host of serious young painters. He came back to his roots in Camden Town, took up the themes which led to his most original work and gave a powerful new direction to English art.

The impetus came from two young artists in 1904. They were on a painting trip at Cany, about twenty miles from Dieppe. Albert Rothenstein, brother of Will, already knew Sickert and was eager to introduce his friend Spencer Gore to such an eminent figure. Gore and Sickert got on famously, playing billiards and discussing the theatre. The young men spent two days in his company and told him about such up-and-coming artists as Gwen and Augustus John, Orpen, McEvoy, Edna Clarke-Hall and others. Sickert had heard of their work but had not seen it and his interest was aroused, especially when he heard that they were bringing fresh vitality to the exhibitions of the New English Art Club. Rothenstein (who later changed his name to Rutherston) recalled: 'It was during this visit that Sickert was persuaded to make up his mind to return to live in London. He was beginning to tire, I believe, of his complete isolation in Dieppe.'

After the summer of 1905, which he spent in Dieppe, Sickert came home.

After nearly seven years abroad, he was ready to make his mark. He rented lodgings and a studio at 6 Mornington Crescent. It was familiar ground; the statue of Richard Cobden, the father of his former wife, Ellen, stood just outside Mornington Crescent Station and his first studio in Robert Street was but a stone's throw away. This move and his contact with younger, enthusiastic painters gave him a new lease of life. He relished the veneration he inspired and while playing to the gallery, as usual, he was serious in his desire to influence a generation of artists. One young painter, Hubert Wellington, never forgot meeting Sickert, who was then at the height of his powers:

Sickert, at forty-six, was a tall, clean-shaven, rather burly man. His brown hair was still abundant and wavy. He moved in a leisurely fashion, but was immensely vivacious. Under bushy eyebrows his eyes watched one with the keen, quizzical look of the constant observer. His mouth, held rather tightly at the corners, was always ready to turn from a slightly ironical smile to a whole-hearted guffaw; this laugh remained his unmistakeable mark, however, later, he was disguised by beards. Altogether a striking, friendly figure, though provocative and even potentially mischievous.

Walter Sickert, *Jacques-Emil Blanche* (c. 1910)
Oil on canvas, 24 × 20in (61 × 51cm). Tate Gallery.

Immediately, he made an impact, rejoining the New English Art Club and exhibiting a major music-hall painting and some of his Venetian figure studies. He quickly sized up the situation, noting that the New English Art Club was now well established and that a certain conformity had set in. Though it was an admirable society, it was run by gentlemen for gentlemen and he found that new blood was not always welcomed: 'A glance round the walls of any New English Art Club

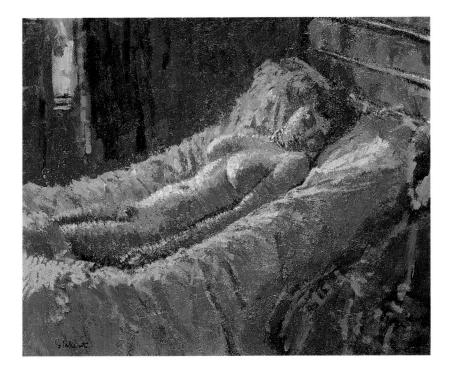

Walter Sickert, *Mornington Crescent Nude* (c. 1907)
Oil on canvas, 18 × 20in (46 × 51cm). Private collection.

exhibition does certainly not give us the sensation of a page torn from the book of life.'

The young moderns had nowhere to show their work regularly to modest collectors. Sickert assumed leadership effortlessly; he simply kept open house at his studio in 8 Fitzroy Street on Saturday afternoons. These meetings were convivial – strong tea and slab cake were served, and the friendly, informal atmosphere attracted a small group of loyal clients and enthusiastic painters.

The arrangement was so effective that in 1907 he regularized it, called it the Fitzroy Street Group and took rooms at Number 19 to store and exhibit pictures. Each artist contributed an easel on which to display one painting at a time, the rest remaining in the stacks behind. The rent was shared between the Members, who included Spencer Gore, Harold Gilman, William Rothenstein and his brother Albert, and Lucien Pissarro, son of the great impressionist, Camille. Sickert was quite clear about his motives:

I do it for two reasons. Because it is more interesting to people to see the work of 7 or 9 people than one and because I want to keep up an incessant proselytizing agency to accustom people to mine and other painters' work of a modern character...to get together a

milieu rich or poor, refined or even to some extent vulgar, which is interested in painting and in things of the intelligence...

He also made the point that a following has to be built up gradually.

We shall slowly do very useful things in London. Accustom people weekly to see work in a different notation from the current English one. Make it clear that we all have work for sale that people of moderate means could afford (that a picture costs less than a supper at the Savoy).

In addition, he had an inborn sense of being a teacher and believed that 'I am sent from heaven to finish all your education'.

The nucleus of painters who had gathered round Sickert in Fitzroy Street evolved into the Camden Town Group. There were sixteen in all and they considered themselves to be the best and most forward-looking artists of the day. The founder members were Spencer Gore, who was chosen unanimously as the President, Walter Bayes, Robert Bevan, Harold Gilman, Charles Ginner, Lucien Pissarro and James Manson. Sickert was their leader and mentor. Invited members were Malcolm Drummond, James Dickson Innes, Augustus John, Henry Lamb, Wyndham Lewis, Maxwell Gordon Lightfoot, William Ratcliffe and John Doman Turner. Women were excluded. Gilman insisted on this to keep out wives, girlfriends and Sickert's numerous female admirers. This harsh ruling also kept out very fine painters such Gwen John and artists of talent such as Sylvia Gosse, Nan Hudson, Ethel Sands and others.

Sickert persuaded Arthur Clifton of the Carfax Gallery in Bury Street, St James's to hold the first exhibition in June 1911. A second followed in December and the third and last in December 1912. Financially, the shows were unsuccessful but Clifton continued to support individual members of the Group by offering them separate exhibitions. However, the importance of the Camden Town Group was not in its public manifestation. A whole generation of artists found encouragement, artistic self-confidence and a sense of identity through meeting together and sharing ideas. The best of them went on to become original artists in their own right, each making a particular contribution to English art.

Not only did Sickert provide the structure for young painters to meet and show their work, he also influenced their subject matter and approach. His own themes were ones he had already begun to explore prior to his homecoming: music-halls, architecture and one or two figures in an interior. Camden Town gave a new vitality, power and darkness to his work. He developed those preoccupations with working people and street scenes; and the beauty to be found in mean and squalid surroundings for which he is chiefly known.

Sickert's finest music-hall scenes are marvels of atmosphere, colour and construction. His love of spectacle and theatre combined with his understanding of architecture to produce a wholly individual

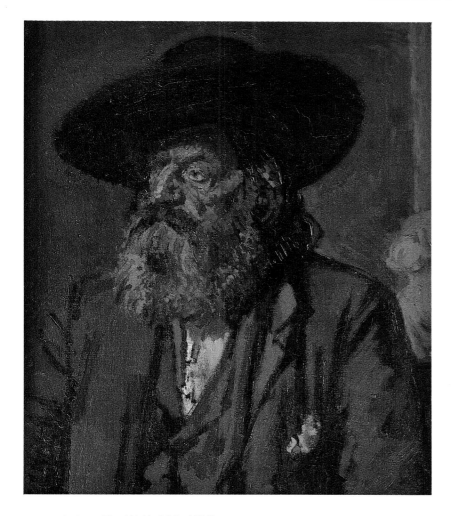

Walter Sickert, *The Old Model* (c. 1906)
Oil on canvas, 30 × 25in (76 × 64cm). Private collection.

Triumphantly, he practised what he preached: that good drawing is swift and sure, 'speed without haste, calm without rest'.

Memory was of great importance to the painter, who should work 'under the immediate influence of recollection' and not wait until 'all the savour has been forgotten'. Sickert was blessed with a highly retentive memory and his music-hall pictures depended on studies made on the spot and a vivid recall of the scene in its entirety. Not many of his disciples could follow him down such a rugged road.

His figures seen in an appropriate setting were influential and inspired many imitations. Such subjects were a nude on an iron bedstead or at her toilet; a working model from the street shown in her shabby bed-sitter; and informal portraits of friends. Sickert also painted London squares and terraces, demonstrating his grasp of architecture and ability to communicate a feeling of place. His own particular conversation piece would show two figures, usually a man and a woman, connected by some tension or suspense. The relationship of the figures to each other and to the background has the effect of a drama. What has happened? How has such a situation come about? These questions puzzle the viewer and bring us into the scene. The poetry of light and shadow on the human form, however, is the chief technical concern of the artist. Sometimes, Sickert would amuse himself by adding a title such as *what shall we do for the rent?* to intrigue his audience further.

His sense of the macabre and indifference to ordinary human decency, when it suited him, is shown in his gross exploitation of the Jack the Ripper killings. These outrages took place very close to his studio and Sickert was reputed to have known the murderer's identity. Whether he was exorcising a guilty conscience, or cynically making use of the current scandal, or was simply fascinated by crime like his hero Dickens, is not clear. Certainly, his picture *The Camden Town Affair* is hideous and degrading. It shows a woman dead on her iron bedstead with the murderer looking down at her. The drawing of the woman's figure is abysmal and the whole effect is squalid and wretchedly ugly. That Sickert, who was loved, comforted and supported by women throughout his life should have painted such an offensive picture is puzzling. Presumably, he never showed it to his refined female friends.

Sickert's paintings of the Camden Town period are unique in English art. There is no trace of sentimentality in his realism: he shows claustrophobic marriages and the squalor and vitality of the back streets. In the 'great relation' between a man and woman, he suggests complexity; both the erotic and the melancholy are present. In showing us the magic of the music-halls, his work is not merely picturesque; you are aware of the spaces, the shadows, the artistry not simply of the performers but of the architects, too. His morose and powerful art has the impersonality we find in the greatest poets. He was becoming increasingly a master of the enigmatic.

interpretation of this dramatic subject. The New Bedford with its gaudy splendour was a favourite haunt. The huge pilasters and giant caryatids, the weight of the vaulted arches, the red plush curtains, the gleaming gilt, the ornate festooning and decorative plasterwork – above all, the life and vulgarity of the spellbound audience – this was a world which thrilled and inspired him. The difficulties of capturing such scenes were immense. Night after night, he took his seat in the darkened auditorium to make numerous drawings in the flickering light. Working with great speed and in cramped conditions, he wrote that he needed 'the suppleness and rapidity of a sword-swallower' to produce his studies.

MARRIAGE TO CHRISTINE

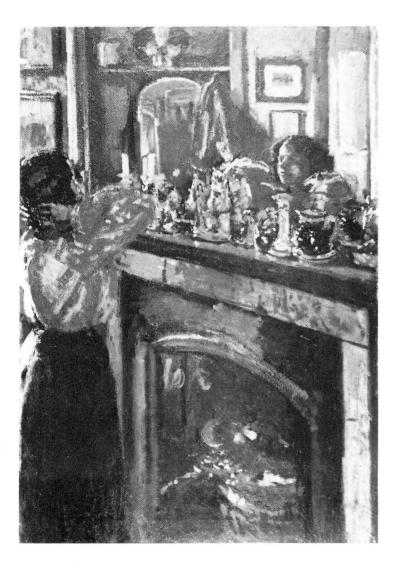

Walter Sickert, *The Mantelpiece* (c. 1917)
Oil on canvas, 30 × 20in (76 × 51cm). Southampton Art Gallery.

Sickert wanted a wife. Since re-establishing himself in London, he had been much in demand socially. It was the era of great hostesses and he soon found his way into the most charmed circles. He was lionised even in that brilliant cosmopolitan set presided over by Lady Ottoline Morrell; but was just as happy with cosy tea-parties. Wherever he went, it was on his own terms. He had no hesitation in telling a hostess that he did not intend to dress for dinner: 'No one thinks what dressing is to people who have neither valets nor motors'.

Instinct told him, however, that he needed a wife to provide his comforts and make a home. So, he set about finding one with zeal and no particular finesse. In 1910, he proposed to three women in less than twelve months. One had the temerity to turn him down, the second jilted him at the Register Office because she 'wouldn't like her people to know that she had been married in Camden Town'. The third became his wife and was the love of his life. Christine Angus was a student at Sickert's school, Rowlandson House. She was the daughter of a well-off Scottish merchant, twenty years younger than Sickert and in delicate health. Sickert pursued her with typical extravagance and flamboyance. Mr Angus believed that Sickert was after his daughter's money, and opposed the match. Christine decided to leave London and spend a few weeks with her brother in Chagford. Sickert turned up at the station, insisted that she must travel first class – and then got into the carriage to accompany her. Irresistible brio! By the time they got back to London, the engagement was a fact. In answer to her father's objections Christine declared that she would rather be married to him with no money than not at all.

They were married at the Paddington Register Office in Harrow Road on 29 July 1911. Spencer Gore was the best man and the honeymoon was in Neuville. This was an indelicate choice in view of Sickert's old relationship with Madame Villain and seems to indicate an underlying indifference. On their return to London, they lived first in Harrington Square for a few months before moving to 68 Gloucester Crescent. It was a threadbare existence and a lonely one for Christine. She must have felt desolate when her husband carried on his daily routine as if nothing had changed. Her life was without the comforts she was used to. Yet she seems to have been happy; at any rate, she never complained and devoted herself entirely to Sickert's welfare.

Sickert was enchanted by Christine's appearance, especially her deep blue eyes and elaborately plaited hair. She was excessively thin and always formal and perfectly dressed. Her movements were angular and her gestures had a curious jerky grace. She never fidgeted or fussed, never lounged or sat or stood carelessly. Even when her face was colourless

from fatigue, she used no make-up and her only jewellery was a huge Victorian brooch, a present from her mother-in-law. She had a flair for dress, enjoyed formal dinner-parties, and was refreshed by high life and refined company. Unfortunately, these occasions ceased after her marriage. Sickert was apt to dodge large parties in favour of small gatherings with his cronies and would refuse invitations that she would have liked to accept. Occasionally, he did go to great houses to please her and the ease, the glitter and the colour did her good.

It was illness that had taught her an iron control. She was already weak at the time of their marriage and as time went on her energy was sapped by a relentless consumption. During their engagement, her family had warned Sickert of the weakness that threatened her, but his only answer was: 'All the more reason that I should look after her'. He did not keep his word. Completely wrapped up in his own affairs, he left her to cope alone, even during the rigours and frights of wartime London. She began to retreat into a sombre world of her own, although she still struggled to join in the lively gatherings at Fitzroy Street.

His extravagence distressed her; he continued to order collars and ties in profusion, to keep taxis waiting all over the place, regardless of time or expense. When they went house-hunting, he was concerned merely with the look of the place; Christine had to deal with the practicalities.

Although Christine wished for children, Sickert did not. He seems to have wiped the memory of his son Maurice from his mind. How could anyone have guessed that he was a father when his students heard him air his pet theory that 'You can't have four generations of painters [Sickert was third generation], it wouldn't work . . . a son of mine would probably be an imbecile'. At this time, his son Maurice was facing the horror and suffering of the First World War.

Christine died aged 44. Sickert never really got over it and said that his mainspring was broken. Surely he felt remorse too that he had so neglected her. They were living in a chilly house outside Dieppe, the Maison Mouton in the centre of Envermeu. He had left Christine to superintend the removal from London to France entirely alone. By this time, her health had deteriorated so seriously that she was often unable to speak from weakness. She needed care and attention but her husband was away making drawings of dance-halls and casinos.

What money they had, he squandered on fantastical schemes. Their new house had once been an inn with stabling for two hundred horses. Sickert immediately fancied himself in the role of a horseman and ordered some expensive riding-breeches. Christine had hoped to pay for the expensive repairs that the house required, by selling the materials from the outhouses which was valuable at this time of shortages. When she eventually reached the house from London, she found that Sickert had ordered the stables to be pulled down to give a clearer view of the valley behind. He had given away the materials.

The cold house and the bitter winter of 1918 proved too much for Christine. The following summer she failed rapidly, and in October, she died. Sickert had not told her family of her illness and all of a sudden the following wire was received by Christine's sister, Mrs Schweder:

> Sinking painlessly most slumbering analyses spinal fluid reveals Kochs tubercle bacillus will wire you when death takes place shall cremate at Rouen the funeral at Anglican Church Dieppe can be postponed week or more after cremation ashes will remain in Envermeu Cemetery unless your father has any other desire Walter.

In his old age, after he had made another successful marriage and avoided all the places they had lived together, he began to speak of her constantly, as if incredulous that she had left him. He said that Christine's inspiration had helped him to continue; it seems that her presence in death was more real than she had been in life. He wrote:

> The fact that she loved me not only as the classic song goes 'makes me of value to myself' but gives me a kind of courage & energy, because I know so well what she would wish me to do. I know as well as if she were beside me. She cared about my work & everything I may still achieve will go to the credit of a name she honoured me by bearing.

During his 'unforgettable days of anguish' immediately after Christine's death, he was comforted by the devoted Sylvia Gosse, who moved to Dieppe to be near him. Mrs Swinton, his cultivated musical friend, sent him 'a dear and understanding letter when my world crumbled into dust'. His reply provides an insight into his mind at this time: 'Of course you read Marcel Proust who is the French writer of the century. Do you remember his description of the first moving in, that you are conscious of, of the malady that is to finish you...' By recourse to art, in this case literature, he is able to detach himself from his own anguish. It was part of his nature and an aspect of his professionalism. This is brought out in a reply he made to Blanche, who was regretting the changes in the Dieppe skyline and had started to reminisce about the past:

> Ah! You are a lucky one, to be still able to FEEL! You would transport me, with the ardour of youth, to the London of old romance, to music-hall nights, to the singing boats of Venice. Do you still cling to all that? I tell you there are no subjects pictorial in themselves. It is the painter who makes use of them for his own ends. Dieppe and Venice were convenient to me. That is all.

The cold deliberation of this statement is revealing of Sickert's determination to pursue his vocation as a painter, no matter what the cost to himself or others. It was this utter conviction combined with the highest intelligence and the most exacting standards that made Sickert such an inspiring teacher.

A BRILLIANT TEACHER

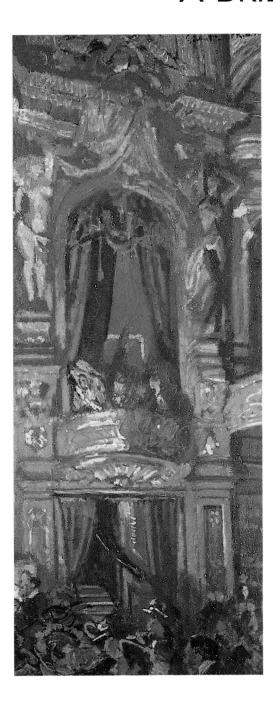

Sickert was such a teacher 'as would make a kitchen-maid exhibit once', said Enid Bagnold. She also described herself as a 'Sickert-product'. Presumably, she meant that his overpowering personality and conviction 'made' his pupils into what he wanted them to be. The bigger talents either resisted such undue influence and rebelled, like Harold Gilman, or took what they needed, developing their own gifts, yet still remained close to him, like Spencer Gore. In between were a host of pupils, disciples, followers and supporters whose impulse towards painting was confirmed and encouraged. Sickert was the lighthouse of their existence just as Degas had been for him.

Sickert had everything that was needed to make a brilliant teacher: a deep love and mastery of his craft; a profound knowledge and understanding of *la peinture* and the tradition which had nurtured it; a lucid and racy style of exposition and the authority that came from first-hand acquaintance with the great French painters. Paris was the sacred soil: 'One should stick to the French School' for 'we all are good only inasmuch as we derive from them'. His time in France had been of supreme importance for his own art: 'I have learnt here what I couldn't have learnt in a lifetime at home'. Now he had returned and was eager to pass on what had been so hard won.

His background helped to make him a complete professional; this naturally inspired confidence. Sickert came from a line of painters and although he was only twenty-three when he first went to France, he was already well prepared to make the most of all he saw and heard. Oswald Adelbert Sickert, his father, was a capable painter and draughtsman who had studied in Paris with Couture. His grandfather Johann Jurgen Sickert was also a painter, and head of a firm of decorators employed in the Royal Palace of Denmark. Sickert's family was harmonious and united and he eagerly absorbed his father's and grandfather's sober and workmanlike attitude towards the arts. Sickert had no doubts about his own place in the great continuum:

> I am a pupil of Whistler – that is to say, at one remove, of Courbet, and at two removes, of Corot. About six or seven years ago, under the influence in France of Pissarro, himself a pupil of Corot, aided in England by Lucien Pissarro and by Gore (the latter a pupil of Steer, who in turn learned much from Monet), I have tried to recast my painting entirely and to observe colour in the shadows.

Walter Sickert, *The New Bedford* (1916/17)
Oil on canvas, 73 × 28in (185 × 72cm). Leeds City Art Gallery.

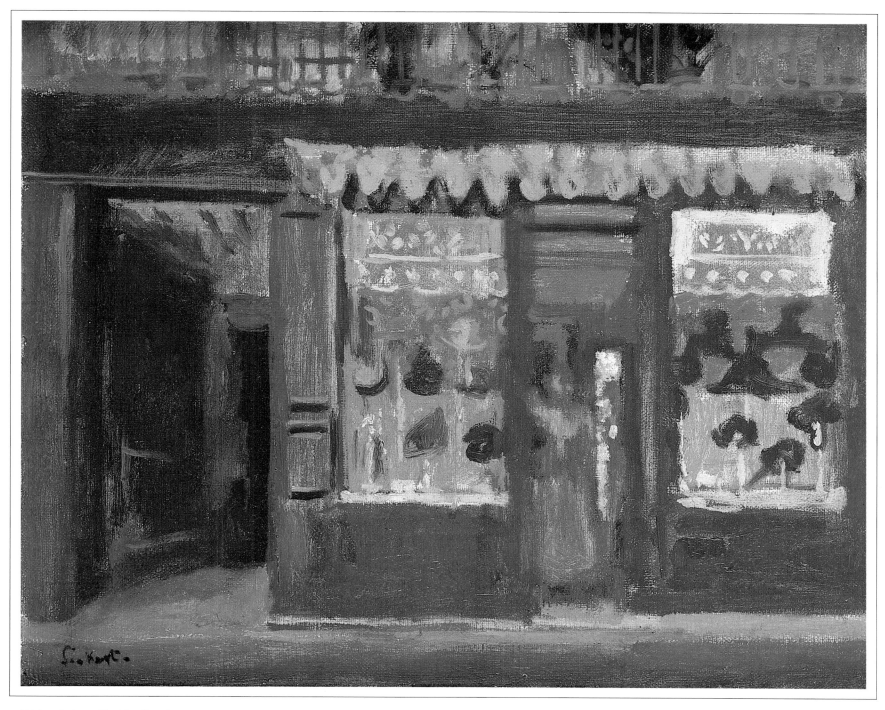

Walter Sickert, *The Hat Shop* (n.d.)
Oil on canvas, 13 × 16in (33 × 41cm). Private collection.

Walter Sickert, *The Trapeze* (1920)
Oil on canvas, 25½ × 32in (65 × 81cm). Fitzwilliam Museum, Cambridge.

Sickert wrote this in 1910; that a tried and tested painter of fifty should still be developing and learning from his juniors shows his mettle. He struggled endlessly to strengthen his vision and technique. Willing to learn from his pupils, he was nevertheless quite ruthless with time-wasters.

Yet he was encouraging and gentle with those who really wanted to learn. 'At least they are sincere', he would sigh as he stood before some beginner's faltering attempt. He held classes in his studio at 8 Fitzroy Street and his prospectus was designed to weed out the dilettante, though with the greatest care and discretion. He favoured the hard worker even if little facility was shown; he held that if there was a steady urge to paint, talent was dormant somewhere, and he was most suspicious of those who although gifted did little or worked in fits and starts. His prospectus was clear and direct:

Bath, 1917

Mr Sickert retains the option of accepting such students only as are likely to profit by his method of training. To avoid correspondence, it may be found convenient to state the principles by which Mr Sickert would be guided in his acceptance of students. Unlikely to benefit would seem to be: (i) painters whose practice is already thoroughly set in methods (*sic*) its continuance in which Mr Sickert would be unable to encourage and indisposed to check;

(ii) students who have already studied with him long enough to have absorbed – or failed to absorb – the little he has to teach. An intelligent student who cannot learn whatever is to be learnt from a teacher in three years will learn no more in thirty. Mr Sickert prefers not to be party to the creation or perpetuation of what may be called the professional or eternal student, with no other aims than to haunt the art schools as an occupation in itself.

Ability in drawing and painting were not enough; other qualities were needed for success. Concentration was all-important. Determination and single-mindedness were needed for a vocation which demands the commitment of a lifetime. 'I am more interested in talent at forty than in talent at twenty' was one of the many remarks by Degas that made a great impression on Sickert. It summed up his own experience of the results of teaching after a number of years.

Sickert had two main objects in view. One was to encourage students to paint without nature in front of them; the other was to help them to become independent of the schools as soon as possible and to find their own level in a wider world. He had seen too many students who relied more and more on direction and less and less on themselves. He often spoke of those who had been too long in the 'incubator' so that they were bewildered and lost when it came to attempting the steep climb from amateur to professional status. They could not cope with the lonely struggle, away from the stimulus of teachers and classmates, and gave up.

Drawing was of paramount importance. Drawings were to be considered as documents and must contain as much information as possible. Drawing was a means to an end; a preparation for picture-making. Sickert insisted that the student should be studying composition *through* drawing not *after* drawing: 'From the first stroke of his pencil he should be making studies for pictures of his own'. A student Clifford Hall gave a description of Sickert when he was teaching at the Royal Academy Schools in 1926:

He had great authority and great charm. The three models who normally would have posed singly in three separate studios he posed together in a group. This group was placed in the centre of the studio. We had been used to having the model placed against a drapery background; now we were told that we must relate this group of three to whatever happened to be near or behind them – other students, or a corner of the studio, maybe.

The insistence was on drawing and still more drawing. Drawings were to be considered as 'documents'. They must contain as much information as possible ...

Commencing a Drawing

We could begin with whichever portion interested us most. We must proceed to relate the shapes immediately next to the one we had started with and so on, constantly relating shape to shape,

'with no jumps', until 'the drawing bumped up against the four edges of the paper'.

The drawing must be commenced with a faint 'tentative line'. Next the values were put in, starting with the darkest, 'to give the map solidity', and finally a firmer more searching 'line of definition' was added

Pencil or black chalk, not too soft and with a good point had to be used and india rubber was not allowed.

Colour sketches, in oil colour, painted in one sitting, on canvas or board 'primed the colour of a cigar box' were to be made. These were to be used in conjunction with the students' drawings when putting together the finished picture. This was to be painted away from nature. Sickert adopted the traditional French method of teaching. 'I am not going to stumble in and out between easels whilst you are working.' He told the students how he wanted them to work, then left them to get on with it. At the end of the week, when the models were no longer present, the students were expected to show him everything they had done. Each student then received an individual criticism. Each student was given advice according to his particular needs, but all were expected to listen to all the individual criticisms which were full of wisdom. The students were told to write down what he had told them and post their notes to him.

He divided pictures into two sorts: The ones in which something was going on and the pictures of 'yearning' in which nothing happened. 'Let us have people doing something. Working, making love, misconducting themselves, but *doing something*.' Figures must not be shown in a vacuum, but must always exist in relation to their surroundings. The picture could be built up from any starting-point, perhaps a table, chair or bed.

Students were not allowed to indulge in an orgy of colour. They had a restricted palette of four colours, with orders to explore these thoroughly. Winston Churchill was Sickert's most illustrious pupil and he, too, chafed against his austere methods. A dedicated amateur with an instinctive colour sense, he loved to splash about with vivid colours from the start. But he was less enthusiastic about drawing and the steady building-up of a composition had little appeal for him. Yet these two strong-willed individuals got on well, though Churchill was happier with more pliable instructors. They always kept in touch and there is a telegram to Sickert which reads: 'I am bracing my eye on Rubens and Rembrandt – Churchill'.

During his final years when he lived outside Bath, Sickert, although very ill, still thought he was teaching. Until his final collapse, he would start off gaily to the old barn to find his students. His third wife, Thérèse Lessore, nursed him patiently through several strokes. He was in his mid-60s by the time they married in 1926, his restlessness curbed by bodily fatigue and his painting erratic.

Thérèse Lessore was a painter too and Sickert admired her pictures, finding in them movement and a fascinating economy of style. What particularly fascinated him was 'the echo of movement passed and the promise of movement to come'. Her interiors had a strange fey quality; they were small in scale with an elusive charm, very much her own. After she married Sickert, she merely turned out echoes of his style. Music-halls, though, were too vast a field for her; they used up her energies and her small but acute talent was smothered. As time went on, she became exclusively interested in him and when he became old and exhausted, she was dedication itself.

The strain on her was heavy, with wartime restrictions, very little money and a sick husband. Until the end, he persisted in his old ways, disappearing suddenly into Bath to potter among the second-hand bookshops and scrutinise the architecture, looking for subjects that he would never paint again. She believed that his last years in Bath were happy because he thought he was still painting and teaching. Sometimes he would plead to be taken back to Fitzroy Street, but that was part of the old restlessness that nothing could assuage. She would follow him out to the garden where he went to look for his pupils:

When I went after him, I would find him waiting for the students who never came. I tried to cheer him with promises that they would be there next day, and take his mind off the subject by talking of something else. He seemed contented for the time being but next day he always went back to the barn to look for them again.

Marjorie Lilly, a close friend and a brilliant writer and interpreter of his work, describes him as he appeared on her last visit a few months before his death in March 1942:

Sickert was sitting with his back to the window, dark against the ebbing day. He was so still in his pose of dumb acceptance that he seemed like a figure in one of his own interiors; drifts of light floated over his head and shoulders but the rest was lost in shadow, all depths and blurred contours, losing and finding themselves in the gathering dusk. He was thinner, the concavities of his face more sharply marked, but his hair was thicker than ever, rising from his head in close-piled curls, his eyes blue and clear in their deep orbits. He moved slightly and the shadows fled. I thought what a portrait he would make with his lime-green checked coat, the crimson rug wrapped round his knees and the background of trees beyond the window.

Suddenly, he started to tell her about the picture he could see in the dying light beyond the trees. His description came out in a torrent of words, moving in its broken vehemence. But the composition needed a figure and he indicated that he wanted her to seat herself at the foot of the bed. His face lit up; he now had what he needed: the fall of light on the object. The picture was complete.

THE PRINCIPAL PLAYERS

SPENCER GORE: A PAINTER OF CHARACTER

Spencer Gore was important as a gifted, original painter and because his charm, intelligence and generous nature made him a natural leader. He was chosen as the President of the Group and worked assiduously on its behalf. Sometimes an artist's background, personality and circumstances are all favourable to the development of his art. So it was with Spencer Gore. Sickert, who had great admiration for his work, said that his growth to maturity was an object-lesson in the management of a life and a talent.

A distinguished and prosperous family background gave him a smooth start in life. His father was a successful business man and an outstanding athelete. S.W. Gore was the first Wimbledon Singles Champion in 1877 and his son inherited his sporting prowess. Spencer Gore excelled at cricket, was a Public School Boxing champion and won the Harrow mile. He had an eminent uncle, too: Charles Gore, Bishop of Oxford. In common with him, the nephew had a mellifluous 'fluty' voice. After Harrow, Spencer Gore went to the Slade School. He was taught by Tonks, Brown and Steer, gaining a solid grounding in drawing from the object. He was one of a generation of brilliant students, such as Augustus John, William Orpen, and Harold Gilman who was a close friend. A few months' travel in Spain to study the Goyas and then a spell in France to absorb the exciting new developments was an ideal way to round off a painter's education. This privileged and leisurely way of life was abruptly brought to an end in 1904 by a family shock. His father failed in business, deserted his family and died within two years, quite alone and in great pain. At this point, His Lordship the Bishop stepped in to point out his nephew's duty. This was to abandon painting in favour of a more lucrative profession and to devote himself to the welfare of his mother and sisters. Spencer Gore refused absolutely. Fortunately, his mother was granted a good pension and moved to a pleasant house in Hertfordshire.

When Spencer Gore turned his back on a conventional career and chose the insecure life of an artist, he became overnight a disciplined, immensely hard-working professional. He was twenty-six. By great good fortune, he met Walter Sickert just when the loss of his father was most acute. Almost twenty years older, knowledgeable, cultivated and experienced, Sickert was an ideal mentor for a young man just starting out. Gore and Sickert met in 1904 and remained the closest of friends for the rest of their lives. They were neighbours and painted together in Camden Town; both wrote for the same journal, the *Art News*, and each was best man at the other's wedding. Sickert had abandoned his own son; Spencer Gore had lost his father. They each found a surrogate and a congenial painting companion.

The stimulation and heady atmosphere of Camden Town with the authority of Sickert at the centre were key factors in Gore's development

Spencer Gore, *Self-Portrait* (1914)
Oil on canvas, 16 × 12in (40 × 31cm). National Portrait Gallery.

(Opposite)
Spencer Gore, *Balcony at the Alhambra* (1911)
Oil on canvas, 19 × 14in (48 × 35cm). York City Art Gallery.

as a major painter. Although he was influenced by Sickert's subject matter, Gore's vision was more poetic and lyrical and he was a superb colourist. Up to a point, he was a typical Camden Town artist. All realistic painters in the sense that they drew inspiration from the everyday life around them, they painted their shabby bed-sitting rooms, the London streets and squares, pubs, shops and railway stations. The neighbourhood was run down, the heavy Victorian terraces were dilapidated and the working men and women who acted as models were often tired and dispirited. Sickert, who influenced all the Group in their choice of subjects, conveys the dreariness and boredom while imbuing his best pictures with a sombre dignity. Gore, on the contrary, seemed to see the shabby interiors, the weary girls and the grimy streets through a shimmering haze. He intensifies the beauty, brings out the poignancy and in his finest work gives us the full experience as he apprehended it. Gore was both sensitive and deeply intelligent and his personal response gives quite ordinary scenes a particular interest.

Character was the most important element in a picture, he felt. By character he meant 'the stamping of a place either real or adapted from compositions with a feature or series of features peculiar to itself and to nowhere else even if it necessitates something awkward or ugly.' In other words, he is searching for and revealing the particularity, the essence of a scene. His working method was to paint directly from the object whenever possible. This meant painting out of doors in all weathers, though Sickert deplored this habit. A vivid insight into his custom is provided by a letter to *The Times* on 10 February 1926. The correspondent, Walter Bayes of London County Council, is expressing a hope that a row of shops about to be built at Mornington Crescent, in place of the trees of a garden, might be called Spencer Gore's Grove. For, he goes on to say, 'There must be many like myself who never pass them without recalling the bright spirit of Spencer Gore, who standing at his easel in the most inclement weathers painted so many charming pictures there to the accompaniment of the hum of the trams.'

Sickert and Gore influenced each other in technique. From Sickert, Gore learnt to make small drawings from the object which he then worked up into larger paintings back in the studio. This was the only way to tackle certain subjects such as music-halls. Sickert acknowledged what he had learned about colour from Gore, who had taught him to analyse colour in the shadows. Both painted similar London scenes in Mornington Crescent, for instance – but Gore never gave up his preference for painting these on the spot.

Both loved the English music-hall. But whereas Sickert frequented the New Bedford which was on his doorstep, Gore favoured the sumptuous Alhambra Palace in Leicester Square. He would queue for hours in order to get the same 2s 6d seat in the balcony. From here he would make small sketches of the performers, the wide stage and the colourful backdrops, aiming to catch what was spontaneous, alive, magical in the scene. Dancers, acrobats, ballerinas, whatever was absurd, bizarre or fantastical

appealed to him. He shows a solitary, tremulous singer warbling in pale pink on a lilac stage; a hefty ballet dancer, fortyish, with bulging calf muscles poses in a frothy white tutu, her fixed grin hiding the strain. When he turns his attention to the audience, the effect is equally original. Three spectators lean at a perilous angle over the balcony – one has rosy red cherries dangling from her hat. You feel Gore's intense interest and concentration, his delight and sense of fun. These music-hall scenes are quite individual and could not be mistaken for the work of anyone else. In Gore's family, everyone had been expected to sing, dance or act. There had been a troupe of strolling players among his ancestors and Gore's own speciality was the comic policeman. Humour, spectacle, excitement are conveyed because he feels and understands what is going on.

Gore believed that art was rooted in the visual world. The interest is in what you see, not in what you know, and if a painter observed nothing special his pictures would have nothing special to say to anyone. Like Wordsworth, he felt that nature was our greatest teacher. He practised what he preached for no matter how stylised his pictures became, they always show evidence of close observation. His views on painting were deeply felt and expressed with lucid intelligence. They were conveyed in the course of a correspondence with a deaf fellow-painter, Doman Turner. Gore taught him to draw by means of a series of letters. His writing shows him to have been a fine teacher and critic. The pieces that he wrote for the *Art News* during 1910 are very revealing of the artist.

Gore emerges as clear-thinking and knowledgeable, making informed appraisals of current exhibitions, such as the sensational show organised by Roger Fry at the Grafton Galleries in 1910. Gore delights in the work of painters as diverse as Gauguin and Cézanne. He makes confident judgements, though with modesty and detachment. He is enthusiastic about the new developments in painting; aware of the value of tradition yet not deferential; he talks about Manet as being the 'the most constant source of disappointment' to him, for instance. Equally, he reveres genius, mentioning Turner's 'stupendous imagination'.

There are three main tenets: the importance of character in a picture; nature as a touchstone; and the belief that painting must be personal. Character matters most, 'graceful forms are less important than character'. The French Impressionists are important because, 'you feel how much they were struck by some effect of light, by some shape, by the character of some scene or person. This was insisted on. This was the reason for the picture, even to exaggeration. So that even the dullest subject or the commonest object became interesting.'

The study of nature, he felt, was essential both in seeking the essential character, what Gerard Manley Hopkins calls the 'inscape' of the subject; and in keeping alive the personal element. Painting he regarded as an expression of individuality.

All of his beliefs found expression in his own work and, because of his conviction and 'dogged industry', inspired his pupils and fellow painters. He, in turn, was inspired by Gauguin and particularly by Cézanne whose

Spencer Gore, *The Artist's Wife* (1911)
Oil on canvas, 16 × 13in (41 × 33cm). Tate Gallery.

preoccupation with colour Spencer Gore shared. He writes:

> Cézanne was a painter who sought above everything else an exact
> harmony of colour, as exact as Whistler's relations of tone. In
> attaining this he often lost the drawing which he would then
> recover with a line. Hence incompleteness. The incompleteness not
> of a shirker but of the man who has pursued a thing as far as he can
> go, and still finds the end just out of reach. And it is the intense
> sincerity with which he pursues his object which gives to his
> painting that wonderful gravity...

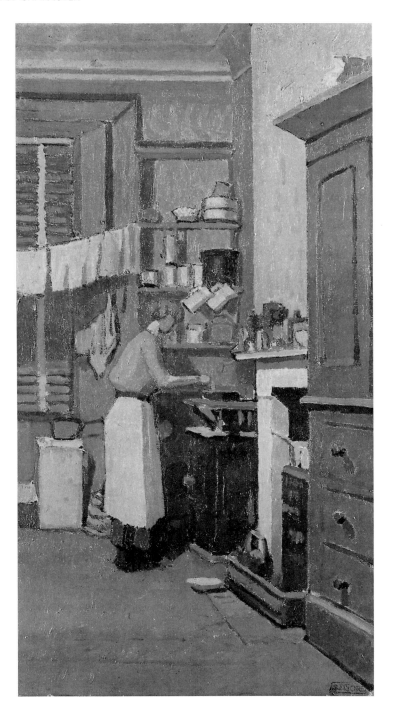

Spencer Gore, *The Gas Cooker* (1913)
Oil on canvas, 11 × 16in (29 × 14cm). Tate Gallery.

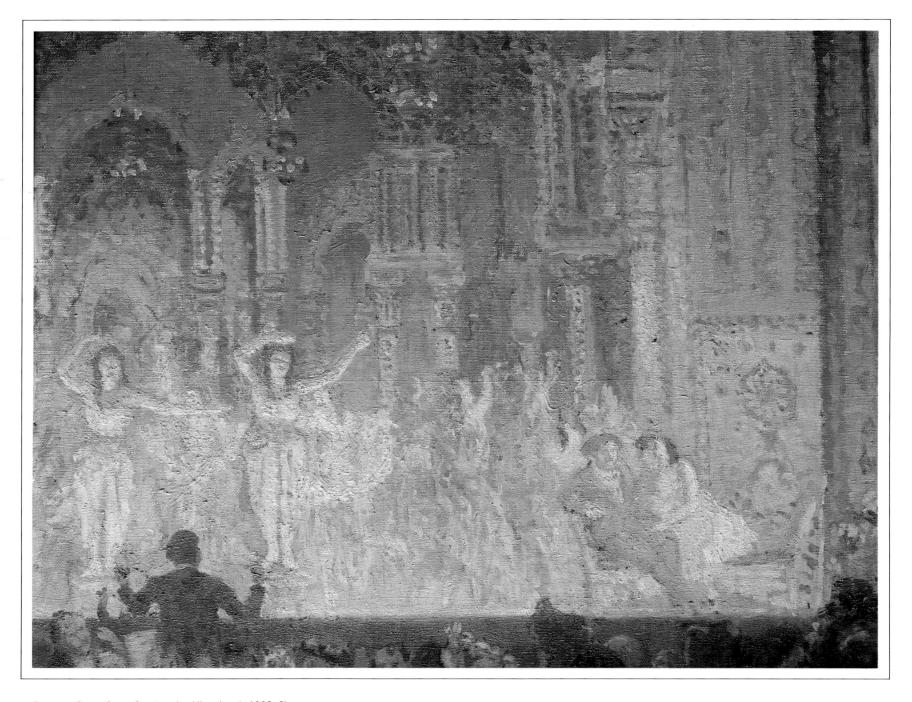

Spencer Gore, *Stage Sunrise, the Alhambra* (c.1908–9)
Oil on canvas, 16 × 20in (40 × 51cm). Private collection.

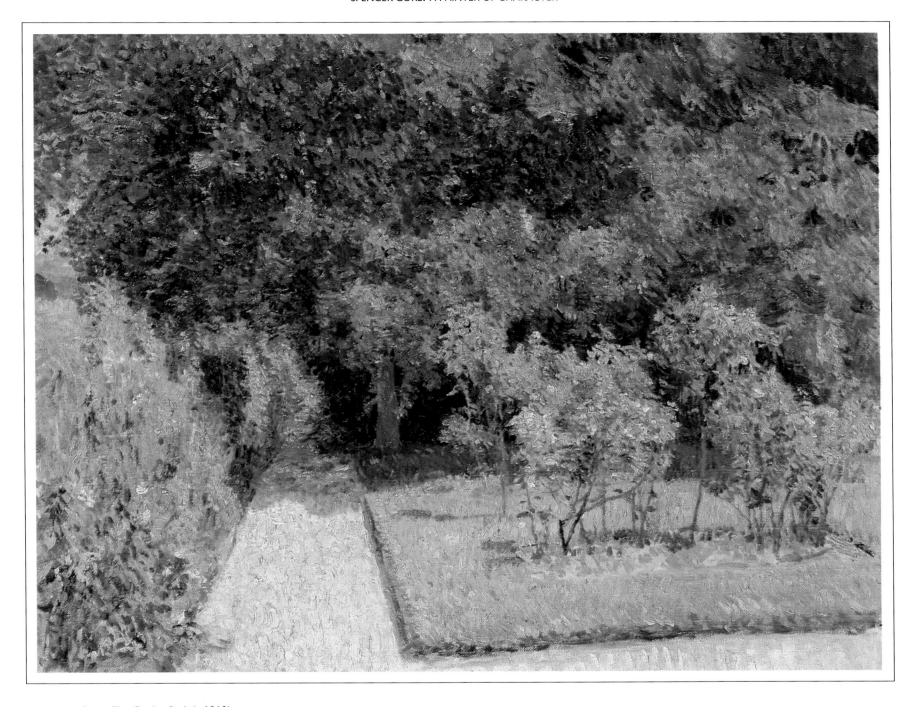

Spencer Gore, *The Garden Path* (c.1910)
Oil on canvas, 16 × 20in (41 × 51cm). Pallant House Gallery, Chichester.

These views were expressed in the regular column that he wrote for *Art News*, which was edited by the influential critic Frank Rutter. Gore signed himself 'Neo-Impressionist' except for the review of the 1910 Cézanne, Gauguin and Van Gogh exhibition at the Grafton Galleries. In this piece, his wide knowledge of both French and English painting comes across as well as his own strongly-held beliefs. Naturally, he wants to identify it as his own and signs it S.F.G. One of Gore's most likeable traits was his tact, a capacity to reconcile conflicts by his wide sympathies. This characteristic emerges in his criticism, too:

> The attempt to separate the decorative side of painting from the naturalistic seems to me to be a mistake. Dürer is supposed to have said just before he died, that he had begun to see how simple nature was. Simplification of nature necessitates an exact knowledge of the complications of the forms simplified. This may be done to produce a greater truth to nature as well as for decorative effect.

This article, dated 15 December 1910, is a distillation of Gore's convictions about the nature of painting, and helps us to understand his own work. In a cogent summary, he argues that one central concern unites all serious painters from Goya to Gauguin, from Sisley to Seurat: 'All of them were equally interested in the character of the thing painted, and if the emotional significance which lies in things can be expressed in painting the way to it must lie through the outward character of the object painted.'

Gore painted a wide range of subjects and was never so urban a painter as Sickert. He was influenced by Sickert in such themes as London squares and streets, figures in interiors, nudes seen against the light and informal portraits. But he was equally at home in the countryside. Wherever he went, Gore painted gardens and landscapes, often taking an idiosyncratic viewpoint and focusing on an odd detail. Sometimes he paints a purely impressionistic scene, in the manner of his close friend, Lucien Pissarro. Before he was married he spent several summers in Garth House, his mother's gracious country house in Hertingfordbury, a quiet hamlet near Hertford. He used to roam around the nearby Panshanger estate, in unspoilt countryside, full of old trees and blossoming hedges. A family friend recalls 'Freddy' Gore, one of a crowd of young people who shared a leisurely social round of river picnics, tennis parties, rose shows and church bazaars. Freddy was 'tall and angular… He would do amusing, whimsical things … He liked to walk on stilts which made him tall as a giant and once his straw boater… fell off in his stride and he stepped onto it'.

In Hertingfordbury, Gore painted the garden at Garth House, showing two women deep in conversation on a sunlit path. There are rose bushes and the trees are heavy with foliage. It is a lovely summer afternoon. The women are probably his mother and one of his sisters. Kate was apparently 'Plain but with character … and Florence was very pretty and had a good singing voice'.

This tranquil country life must have been an ideal balance to the bustle and grime of Camden Town where Gore had his studio and played an active role in the art politics of the day as well as presiding over the Camden Town Group affairs. He was a founder member of the Allied Artists Association (AAA), which was formed by Frank Rutter in order to give all artists the opportunity to exhibit their work without having to go through a jury system. The first enormous exhibition of 3,000 pictures was held in the Albert Hall in 1908. It brought together numerous talented artists such as Gilman, Bevan and Ginner who would not normally have encountered each other. They went on to form friendships which helped them to gain confidence and recognition. Spencer Gore was a moving spirit in the early years of the AAA and applied himself to it with 'feverish energy'. Ashley Gibson, a young journalist and close friend, describes Gore at this time:

> His enthusiasm infected everybody concerned, but what was even more helpful was his tact and the sheer sweetness of disposition whereby he contrived, simply by being himself, to resolve innumerable threatening differences over policy and nip in the bud so many of the incipient squabbles naturally arising wherever the artistic temperament forgathers in force.

Gore captured the 'character' of the different places in which he worked. Because he had an idealising strain, he finds beauty and gives back beauty. An example of this is the view of a London sunset in Harrington Square, which he painted from the balcony of 2 Houghton Place. Gore had moved there after marrying Mollie Kerr early in 1912. His happiness and contentment seem to lie behind this stunning picture, which captures the loveliness of the dying sun over a city square. The mood is serene; a celebration of a glorious evening in summer. The painter's joy in the visual world is conveyed with deep but quiet feeling.

By the time he married, he was thirty-four and had had a long period without the responsibility of supporting a family. This was one reason why his talent developed so steadily. His individual style evolved through experimentation; he was open to new influences but had a sure instinct about his own talent. He took what he needed from painters as different as Sickert and Pissarro, Gauguin and Cézanne. His mature work shows a strength of design, shimmering pure colour in a high key, with that particular Gore characteristic of exhilaration and sheer joy in the created world and in painting itself.

So, Spencer Gore was already an established painter by the time he met Mollie Kerr. A dashing red-haired girl from Edinburgh, she seems to have bowled him over. When she passed him coming out of a friend's studio, he turned to the friend and said: 'That is the girl I am going to marry'. Mollie became part of a wide circle of lively and talented friends when they moved into their first home. Gore painted a picture of Mollie in the kitchen called *The Gas Cooker*. In it you can see her frying

something on an old gas stove. They have rigged up a line for their smalls and there is still a packing-case under the window. Mollie herself is the main focus. She is dressed in a pink blouse, long blue skirt and white apron. Her glossy hair is drawn back into a bun. Gore enjoys painting the kitchen equipment and knick-knacks: jugs, pots and pans on the shelf above Mollie's head and the assorted jars crowding the mantelpiece. There is a kettle in the hearth, a copper pan on the hob and a saucer of milk for the cat by the fender.

Both of them were adventurous and loved to try anything new. Their close friend Harold Gilman organised an outing to the Hendon Flying Meeting in July 1912. They went up with him on a dawn trip from Hendon in a Blériot Monoplane. It was a ramshackle machine and when they landed with a frightful bump, they all cheered. Mollie must have had her share of insouciance, for flying was a risky business and she was pregnant. Gore, who was always fascinated by contemporary life, made a painting of the scene, *Flying at Hendon*.

Their first child, Elizabeth, was born in Letchworth, Hertfordshire in October 1912. They had rented Harold Gilman's large airy house in the first Garden City, a far better place to have a baby than a London flat. During their few months' stay, Gore painted his most daring and experimental pictures, using pure colour, flat patterning and extreme simplification. No matter how extreme the selection, however, these landscapes still reveal the lie of the land, the recession and the distances. In other words, Gore emphasises the decorative but does not completely lose the naturalistic. Some of the subjects he painted were Letchworth Railway Station, the Icknield Way and Crofts Lane. Gore's palette was at its most brilliant with vivid mauves, pinks and blues. Bands of yellow sunlight streak across the horizon, the elms are painted in heavy rich green and patterned clouds sail across an intensely blue sky in *Crofts Lane*. These canvases are exuberant in colour and bold in execution but there is traditional skill in the handling of paint and accuracy of drawing.

Gore's position in the progressive art world was very strong. He exhibited widely; during 1911 and 1912, he took part in the three Camden Town Group exhibitions, held a one man show at the Chenil Galleries and took part in the second Post-Impressionist exhibition. One of the most interesting things about him was that he was able to retain the respect of all groups both for his art and his character. As his fellow artist, Drummond, put it: he was a 'leading spirit whose personal charm and the value of whose work was felt and recognised in circles which had very little sympathy for the ideals of modern art'. On the other hand, his work was still accepted by the more conservative New English Art Club.

So when the forward-looking Brighton Art Gallery wanted to put on an up-to-date show they asked Gore to organise it.

Elegant, bustling, thronged with holiday-makers, Brighton inspired some of Gore's most individual and exuberant pictures. He and his family stayed at Brunswick Square, in the home of Walter Taylor, friend of Arnold Bennett and Sickert. 'Old Taylor' was prosperous, hospitable

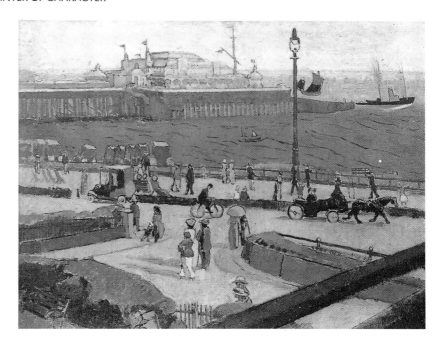

Spencer Gore, *Brighton Pier* (n.d.)
Oil on canvas, 25 × 31 in (63 × 76cm). Southampton Art Gallery.

and something of a collector. He enjoyed mixing with painters and supported the work of the Camden Town Group, inviting individual artists to his comfortable home and getting pleasure from helping them. He was godfather to Spencer Gore's son Frederick. Gore painted his Brighton pictures from the first-floor balcony of Taylor's Regency house.

Taylor had a flair for creating a domestic interior which was stately, luxurious yet relaxing. His furnishings were rich and sober; thick curtains and carpets, lavish ornaments, pictures and flowers in abundance. On the table in his sitting-room were all the latest novels and biographies for he prided himself on being up to the minute. He was always immaculately dressed, moved slowly and had the air of a seaside dandy. He had a cast in one eye, a rosy oval face and beaked nose. There had been a tragedy in his life. His wife had died on their honeymoon and he never spoke of her. Sickert admired his watercolours. He worked on a large scale using charcoal to outline the colours which he painted in large flat masses like a stained-glass window. This seemingly simple procedure was in fact very difficult as many of his friends who tried it found out.

Spencer Gore, his wife Mollie and their baby daughter must have had a wonderful holiday, staying in Taylor's opulent home, being cosseted and well fed. Small wonder that Gore produced exhilarated and personal canvases full of the joy of living and painting. Brighton Pier fascinated him; in his painting of the same name he conveys the mass of its structure in lilac and pale blue, getting the hazy distance as well as the solidity.

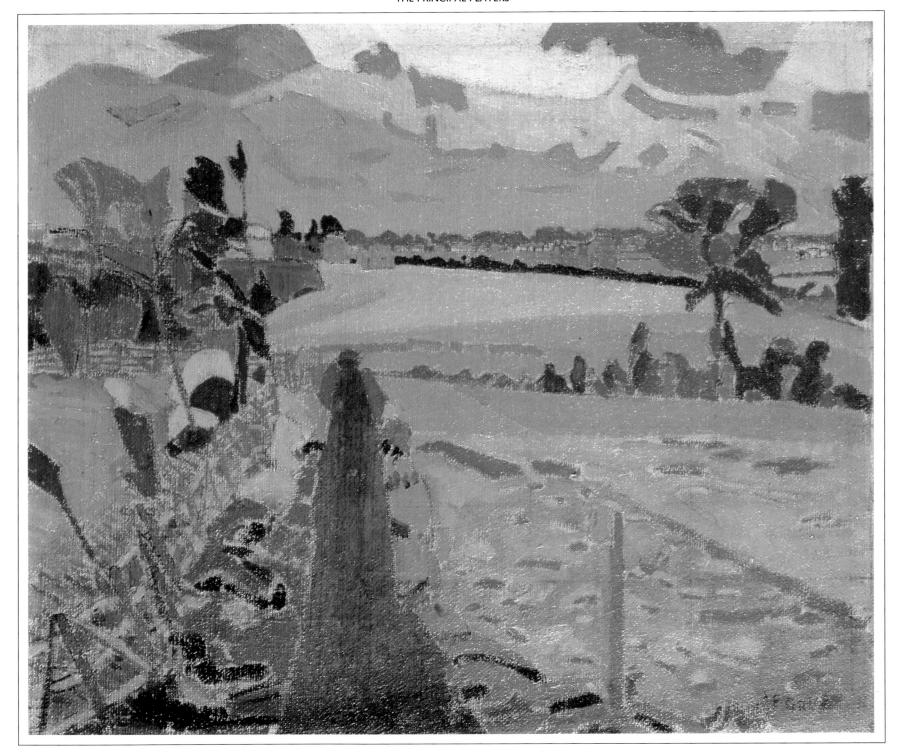

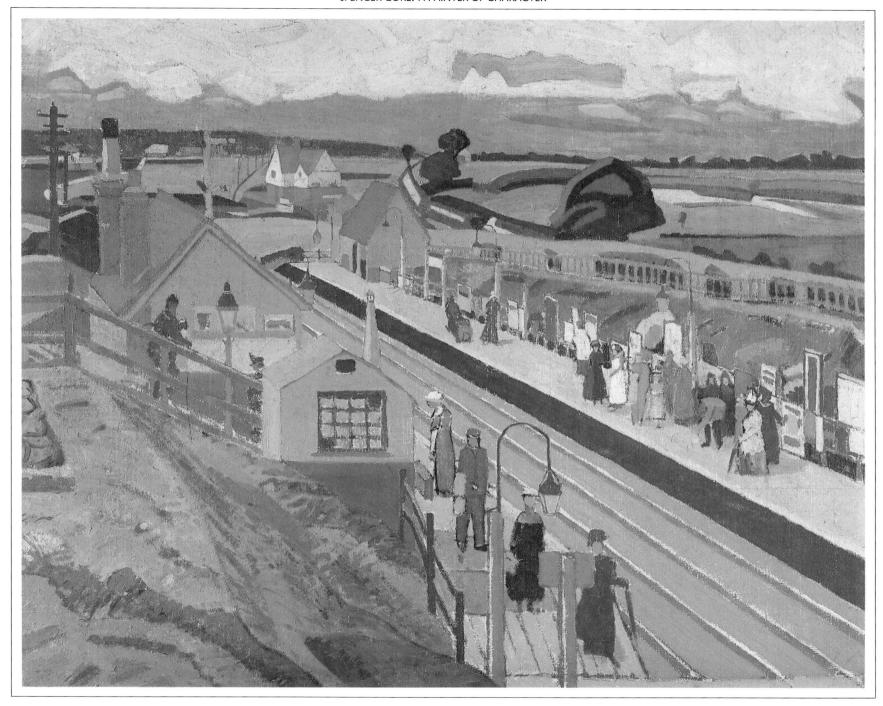

(Opposite)
Spencer Gore, *The Cinder Path* (1912)
Oil on canvas, 14 × 16in (35 × 40cm). Ashmolean Museum, Oxford.

Spencer Gore, *Letchworth Station* (1912/13)
Oil on canvas, 15 × 30in (37 × 75cm). National Railway Museum, York.

Holiday-makers stroll along the front, fashionably dressed; the women in long dresses and carrying parasols; the men wearing blazers and straw boaters. He captures marvellously the atmosphere of festivity and relaxation. A horse-drawn carriage, pink and lilac bathing-machines lined up along the beach make an interesting pattern against the turquoise sea. In such pictures Gore shows that he has a fundamentally realistic approach. As he wrote: 'I always find things more interesting as they are, or, if you like, because they are so'. What he brings to the reality is his own vivid imagination and zest for living. And one of his particular gifts was to find and convey the beauty within the commonplace. Such an artist inspires affection because he opens people's eyes. He was what Sickert called a 'breathlessly listening' artist.

He died from pneumonia at the height of his powers. His habit of painting out of doors in all weathers was to prove fatal. In 1913 the Gores moved from Camden to Richmond. Their home in Cambrian Road is just by the entrance to the Park which provided many lovely subjects. Gore painted the great chestnut trees, the wide vistas, the deer roaming wild; he captures the gleam of vermilion roofs in the distance and the hazy violet of the far copses. These final paintings of Richmond Park have a new grandeur. They seem to bring together all that he had learned of colour and design from the moderns with the gravity and sheer technical brilliance of the great Masters. He reaches his peak in

Spencer Gore, *Richmond Park* (1914)
Oil on canvas, 20 × 24in (50 × 60cm). Anthony d'Offay.

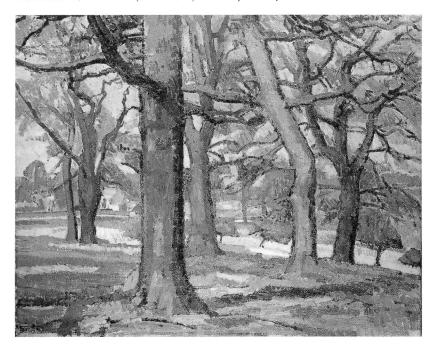

these landscapes and his achievement was recognised: 'Never, except in a landscape by Cézanne, have I felt the weight and density of tree-trunks so powerfully and eloquently expressed' said Frank Rutter.

His death from pneumonia on 25 March 1914 was a grievous loss to his friends and fellow-painters and they felt it deeply. A letter from Harold Gilman to the wife of Pissarro conveys this sense of bereavement:

Dear Mrs Pissarro
 Thank you so much for the kind letter of sympathy from you and your husband. It is a terrible loss to me made more terrible by his having had such a wonderful character – so generous – so unselfish.
 I feel glad for the people who can realise that his personality will live – in his paintings though I cannot feel this yet.

Wyndham Lewis spoke of 'this great artist and dear friend' whose 'gentleness and fineness ... dogged and almost romantic industry' were such an inspiration. For Lewis, Gore had been 'a painter of the London summer, of heavy dull sunlight, of exquisite, respectable and stodgy houses'. He felt that Gore's music-halls had 'brought to light a new world of witty illusion'. His latest work, with its accent on structural qualities, had 'a new and suave simplicity'.

Sickert was shocked and distressed by Gore's death. He went to visit him in Richmond when he was dying of pneumonia after catching cold. Sickert said that Gore had looked pale and run down but he was such a prodigious worker that this was not unusual. He had come in from the Park soaked to the skin after painting all day. He died within forty-eight hours. In his tribute Sickert described him as 'A Perfect Modern' whose influence on a generation had only just begun.

Gore's remarkable achievement was built on a sure foundation. He had been a 'faithful, reverent and obedient' student who referred constantly with 'gratitude and appreciation' to what he had learned from Brown, Steer and Tonks. This 'glad and grateful assimilation' remained a lifelong habit. He seemed to know what to select from the many developments he saw around him and his intelligence and self-discipline were often remarked upon. 'He had the hardness with himself that belongs to breeding or genius or both. I never heard him complain of anything'.

For Sickert, Gore 'became a great draughtsman by the road of colour'. His music-hall scenes were 'miracles of charm and above all, of fullness'. Sickert recalled his garden pictures with pleasure: 'I remember a garden of rose trees, little stiff trees aligned with bare thin stems, planted like a set of skittles, or soldiers in extended formation, each one with its tender and radiant burden, trembling in the glittering sunlight.'

Sickert distils the essence of Gore's individuality when he talks of his 'lyrical and exhilarated improvisation'. It is the life and joy in his best work, the zest for living, the seizing and conveying of what is beautiful which makes Gore's work such a pleasure to look at. By all accounts, the work reflected the man in its integrity and truth.

HAROLD GILMAN: THE ENGLISH VAN GOGH

Earnestness is the most striking characteristic in Sickert's portrait of Gilman. It gets to the very heart of the matter, showing his honesty, forcefulness and sensitivity. A strong uncompromising strain went with idealism and a complete dedication to painting. He also had the irritating habit of preaching on art and politics to his friends. In the portrait Sickert has caught his visionary gaze and Gilman's habitual unshaven appearance is conveyed by black dots on the chin and jawline. Although they were friends for a time, Sickert often became irritated by Gilman's 'intolerable verbosity'. To one drawing he gave the ironic title 'Mr Gilman Speaks'. There was no convenient elasticity about Gilman either as a painter or a man and he detested artifice. Sickert's sophistications had no appeal for him.

Harold Gilman, second son of the Rector of Snargate, was one of a family of eleven children. When he was twelve years old, he suffered a serious injury to his leg which had to be put in plaster, and he lay in bed for months. During this time, he started to draw and paint and developed his capacity for long reflection.

At the Slade School, where he spent four years, his achievements were unremarkable but he formed important friendships; with Spencer Gore, for instance. His was a powerful temperament which grew slowly to maturity. Because he would never make any concession to expediency, he had a hard struggle for many years. Such a nature causes pain to itself and others and Gilman became a passionate humanitarian and painter through the road of suffering and hard experience. Once he had found his artistic voice, so to speak, everything turned to poetry.

He worked for a year in Spain, copying Velázquez at the Prado. This was a valuable training in tone relations, paving the way to more daring colours later on, when he came under the spell of Van Gogh. Gilman worked slowly, putting deep thought into each stroke of the brush and he came to know particular pictures by the great Spanish realist 'as well as I know my own overcoat'. He believed that all honest painters were realists. However much the Masters might vary in their style, subjects or ideas about colour, they were in agreement on essentials. In fact, Velázquez 'would have smiled very kindly' on the new painting, 'which is making men of less supple mind so angry'.

While he was in Madrid, Gilman met and married Grace Canedy on 2 February 1902. She was a painter from Chicago. They had two daughters, Elizabeth and Hannah, and a son, David Richard. This child died at two months old. Another son, David, was born a year later in 1908 at Letchworth in Hertfordshire. There were heavy strains on the marriage.

They intended to settle in the first Garden City and had a house built

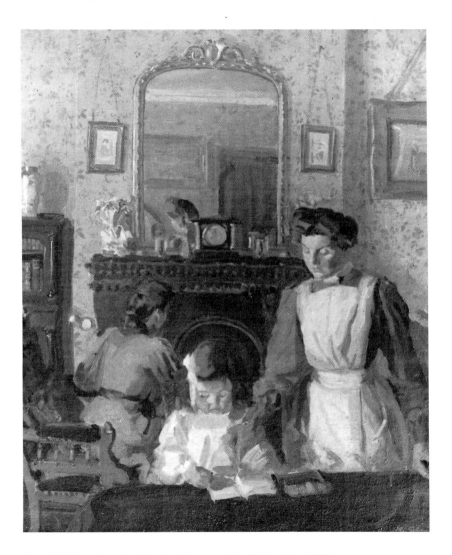

Harold Gilman, *Interior (showing Grace and the Children)* (c. 1908)
Oil on canvas, 27 × 23in (69 × 59cm). Private collection.

for them by the chief architect, Barry Parker, at 100 Wilbury Road. It has the steeply-pitched red roof, small windows and tall chimneys typical of the city, and is set in a long front garden, ideal for the children to play in.

Although a dark shadow had already fallen on their marriage, Harold and Grace were still full of hope for the future. But Gilman's

Harold Gilman, *Leeds Market* (c. 1913). Oil on canvas, 20 × 24in (51 × 61cm). Tate Gallery.

Harold Gilman, *Interior with Mrs Mounter* (c. 1916)
Oil on canvas, 20 × 30in (51 × 76cm).
Ashmolean Museum, Oxford.

responsibilities as a husband and father were in painful conflict with his overwhelming instincts as an artist. He was thirty-two and anxious to establish himself and achieve success as a painter. Grace, his wife, needed care and support. She had borne four children in six years and suffered the anguish of losing an infant. Separated from her family in America, she must have felt wretchedly lonely and resentful. After all, she had been a painter, too, when she married. Now she was a mother, her own wishes had to be set aside. With three children to care for and a bereavement to cope with, she needed help and a proper family life. Attempts were made by her distracted father to persuade Gilman to give up painting and join the family business in Chicago. He refused vehemently. Then Grace recognised that their differences were irreconcilable. Her husband's work was a vocation that he would not abandon. In the summer of 1909, she took the children on a long visit to Chicago and did not return. They were divorced in 1917.

Gilman was devastated by the loss of his children. His tenderness can be seen in the informal portrait he painted of his two little girls whose sweet freshness he captures with the loving attention of a proud father as well as an accomplished painter. His reponse to his wife is more complex. There is a portrait of Grace in which her inner tension is conveyed through her angry expression and nervous fingers. In another picture, the family is gathered round the fire in the comfortable parlour of the Snargate Rectory. Gilman's daughter Hannah faces the painter, while her nurse is intent on helping her to read her story-book. Grace has her back

to him, as she pokes the fire. Whatever their relationship, his suffering after they left him must have been intense and prolonged. He committed himself even more fervently to his painting.

A wide circle of friends and fellow painters was just what Gilman needed to help him to recover from the shock of losing his family. He was fortunate in that he had such friends with whom he could exhibit and discuss painting matters. He buried himself in his work and was active in the various societies that were springing up around Sickert, whom he had met early in 1907. Gilman was a founder-member of the Fitzroy Street Group and a regular attender of the Saturday afternoon 'At Homes'. Here he renewed his friendship with Spencer Gore and met Louis Fergusson who became his patron. He remembers Gilman showing 'interiors – women sewing – women making tea – persons conversing in parlours... the pictures were very intimate – very smoothly painted – without impasto'.

Frank Rutter was another close friend and admirer of Gilman's work. He was an energetic supporter and a fine critic and decided to organise a new society to help these talented painters to exhibit their work to a wider public. He founded the Allied Artists Association which gained enthusiastic approval in Fitzroy Street. Gilman was a founder-member. The Association's first exhibition – a huge assembly of pictures by some six hundred members – was opened in the Albert Hall in July 1908. It was momentous because the Association was open to anyone who cared to join and there was no selection jury. As Sickert put it: 'In this society

there are no good works or bad works: there are works by shareholders.'

The artists took turns in serving on the committee which organised the complicated and tedious business of hanging the thousands of pictures. They went by alphabetical order and in 1910 it was the turn of the 'G's'. This system brought together Gilman, Spencer Gore and Charles Ginner, a meeting which was to give a new impetus and direction to English painting. All three became founder-members of the Camden Town Group and were important as individual artists and for their dedication to the common cause. They were kindred spirits and had similar preoccupations.

Gilman, like the other members of the Group, was influenced by Sickert in his choice of subjects: London streets, shop fronts, eating-houses, informal portraits, nudes and whatever appealed to him in the shabby area where he lived. Gilman had moved into Camden, first into the Hampstead Road by the railway bridge and later to 47 Maple Street, Tottenham Court Road where he lodged until 1917. So he and Sickert were virtually neighbours. In the early years of Fitzroy Street they were close enough friends for Sickert to lend the Gilmans his house at Neuville outside Dieppe for several months.

There was a formidable side to Gilman, an honest straightforwardness which Sickert found both challenging and irritating. Gilman disliked

Walter Sickert, *Harold Gilman* (c. 1912)
Oil on canvas, 24 × 19in (61 × 46cm). Tate Gallery.

Sickert's easy familiarity and seductive ways with women, especially since they were so successful. It was Gilman who was responsible for excluding women from the Camden Town Group. As time went on, they began to clash. They had different views on the Group. Sickert's interest in it was never exclusive whereas Gilman thought no one counted outside it. They became careless of each other's feelings. Gilman took liberties. He formed the habit of taking his friends to the Sickerts' house in Camden Road on Sunday evenings and leaving them there like parcels to be collected later. After the death of Spencer Gore, the conciliatory influence of the Group, the friendship began to wane. When Sickert returned from Dieppe in 1916 he resumed his old post at the Westminster Technical Institute, thereby supplanting Gilman. This too caused bitterness between them.

Gilman moved away from Sickert in technique. He began to use brilliant vivid colours and to apply his paint in thick layers. Sickert deplored this heavy impasto, saying: 'I can't think how you can work over all that rough stuff, Harold. It must be like trying to walk across a ploughed field in pumps.' In one of his sardonic moods, he called Ginner and Gilman 'the thickest painters in London'.

For Van Gogh had become Gilman's inspiration. Reproductions of his paintings were pinned up all over the walls. A copy of his letters was always open on the table and the famous Van Gogh self-portrait with the bandaged ear had pride of place. Before he started to paint, Gilman would wave his brush in the air and bow towards this portrait, crying: '*A toi,* Van Gogh!' It was Charles Ginner who had introduced Gilman to the work of the great French painters by taking him to the exhibitions in Paris. Gilman admired Cézanne and was profoundly affected by the morbid and intense art of Toulouse-Lautrec. But nobody approached the great Dutchman.

Van Gogh was Gilman's mentor and influenced him at a much deeper level than the technical. That tragic painter is the very type of the humane, struggling and troubled artist, outside society and desperately searching for recognition. Van Gogh's intense and deeply felt canvases full of the pain and beauty of life touched Gilman's heart and released his own particular gifts. He identified with him. Like Van Gogh, whose father was a Protestant pastor, Gilman came from an orthodox background and was now bereft of the family life he needed. According to his friend, Marjorie Lilly, Gilman's life, too, was 'one severe battle against poverty'.

Gilman painted for love, as he grew older. Every picture that he produced in his mature style glows with an intense scrutiny and powerful emotion. Life and people were what mattered to Gilman. He became a passionate humanitarian as well as a fine painter. Realistic subjects drawn from everyday life, observed with tender insight and celebrated in brilliant colour were his individual contribution. Gilman was released into his own personal vision by the power of love. One particular passage from a letter affected him deeply. Van Gogh is saying to his brother Theo

that circumstances often prevent men from doing things and they find themselves to be prisoners in a 'horrible cage' formed from an 'unjustly ruined reputation, poverty, unavoidable circumstances, adversity'. But there is an escape from this terrible confinement:

> Do you know what frees one from this captivity? It is every deep, serious affection. Being friends, being brothers, love, that is what opens the prison by some supreme power, by some magic force. Without this one remains in prison. Where sympathy is renewed, life is restored.

Gilman hoped to emulate Van Gogh by creating a character in paint. Surely, he has done this in his portraits of Mrs Mounter. She was his landlady when he lived in Maple Street and was the subject of his most moving portraits. One picture shows her as queen of the breakfast table, presiding over the traditional brown teapot, generous-sized cups and saucers and immaculate white cloth. She is a morose and dignified figure with her neatly set hair and respectable head scarf. Watery blue eyes, gazing into space, a flat nose and resigned mouth are all painted with sensitivity and compassion. It is a triumph of characterisation.

Gilman lavished time, care and materials on such pictures. So he was always hard-up. He had a concern for the craftsmanship of painting and hated the slipshod. An extravagant worker, he used enormous amounts of paint and whenever he had a few pounds in hand, he would splash out on new brushes. He worked slowly, putting deep thought into each stroke of the brush and would paint the same subject several times if it still interested him. At first, he painted from nature, but when he came under the influence of Sickert, he worked from drawings. He used no medium with his oils. When he was finishing a picture, he would pause for several minutes between each stroke, giving the utmost care to each touch to ensure that it was a necessary contribution to the whole.

For Gilman, the only right way of painting was to build up a picture like a mosaic; to analyse the scene before you and then lay on the right pigment in the right place, touch by touch, patch by patch, as the mosaic worker puts in his tiny pieces of stone. He admired old tapestry and would gaze admiringly at a piece of skilled needlecraft owned by a friend, saying: 'Yes, that is how one ought to paint.'

He detested labels and agreed with Sickert who called them 'sandwich-boards' which had to be carried about causing 'useless fatigue' and dissipating energy. Though much influenced by impressionist theories and practice, Gilman would never call himself an impressionist and if he must be called something, preferred to regard himself as a realist.

Frank Rutter, who knew him well for many years, says:

> We cannot classify Gilman as a landscapist or portraitist. He was just a painter. Town or country, people or still life, all was grist that

Harold Gilman, *Study of a nude female drying her right foot* (n.d.)
Charcoal on paper, 11 × 9in (29 × 23cm). Ashmolean Museum, Oxford.

came to his mill: he painted everything and he painted it truly, beautifully, and well. Sometimes I think that more wonderful than anything else he did are the two portraits he painted of his landlady in Maple Street *Mrs Mounter*. They have the reverent psychology of a Rembrandt with the colour of a Vermeer. These portraits are the apotheosis of the charwoman, the transfiguration of homeliness, age and toil into a spiritual loveliness that time cannot wither.

Sickert singled out another picture, an interior, for special praise: 'Gilman touches a high level in his *Leeds Market*. The intricate drawing of the roof in tones of artichoke green and artichoke violet is an expression of something only found by a born painter intensely interested in his subject.' This emphasis on colour was crucial; Gilman looked always for the beauty of the colour in a subject and taught his pupils that it was preferable to err on the side of overstatement of a colour's strength and purity. He admired Van Gogh's vehemence of colour built up in the distinctive strips of paint which so offended Sickert, who declared that 'those strips set my teeth on edge'. Gilman came to regard Sickert's sombre colours as anathema. He worked in pure, bright colours *only*, banishing earth colours from his palette. Wyndham Lewis describes how Gilman would look over in the direction of Sickert's studio, and as he did so:

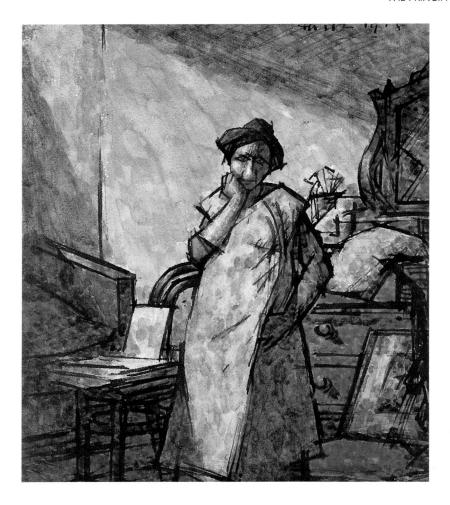

Harold Gilman, *Mrs Mounter in an Overall* (1918)
Pen, black ink and watercolour, 9 × 8in (23 × 19cm). Ashmolean Museum, Oxford.

Friends could meet and paint during the winter evenings of 1916. Everyone enjoyed it and we all attended regularly until we were driven away by bombs. I fear it was not a lucrative venture; fees I think were paid up but expenses were heavy… While the club lasted, however, it was a blessed escape from the pressures of war.

Gilman's subjects were drawn from life. He painted what was near and familiar: portraits of his family and friends, the interiors of the houses he happened to be staying in and landscapes in Sweden and Norway when he visited those countries. He was sensitive to women as he grew older and his studies of them are sympathetic. His nudes are more personal and direct than Sickert's. Often his model looks straight at you, pensive or smiling. Gilman conveys her individuality and sexuality; she is not merely one element in the picture whose name or personality or life experience is of no concern to the painter, which is what we feel with Sickert's nudes. Gilman did not take pleasure in squalor and the women in his pictures often seem to be enjoying themselves. We feel engaged with them because the painter is. In his landscapes and interiors, there is the quality of gusto: pleasure in the subject and delight in the act of painting. The beauty of Gilman's colour is always exhilarating and one feels his powerful concentration on the slow building-up of a composition.

Although life had handled him roughly, things got better for him in middle age. He married again in the summer of 1917. Sylvia Hardy had been a student at the Westminster School of Art, where they got to know each other. They had a son, John. After living for a short time with Sylvia's parents, they moved to 53 Parliament Hill Fields in Hampstead. Gilman must have rejoiced in this new family and the recognition that he was beginning to receive. He was commissioned by the Canadian Government in 1918 to record the Naval Base at Halifax, Nova Scotia. This big picture with its intricate composition and radiant colour was his last.

At the age of forty-two, Gilman fell victim to the Spanish influenza which was ravaging the country. Both he and Ginner were nursed by Bernadette Murphy, a great friend of the Camden Towners. She ran to Number 15 Fitzroy Street where Marjorie Lilly had a tiny studio and told her that Gilman's temperature had dropped to sub normal. He was half-starved and unable to resist the disease. He was taken into hospital and within a few days, he was dead.

The death of Gilman was a grave loss to English painting. He was the acknowledged leader of the best and most promising painters of the day and his character with its mixture of intense seriousness and exuberant goodwill endeared him to a wide circle of friends. Frank Rutter expressed their grief when he mourned the loss of 'the painter we valued and of the man we loved, of the great colourist with his magic of harmony, and of the great-hearted democrat with his tenderness and love for all humanity.'

a slight shudder would convulse him as he thought of the little brown worm of paint that was possibly, even at that moment, wriggling out on the palette that held no golden chromes, emerald greens, vermilions *only*, as it of course should do,

Gilman exhibited regularly and when the Camden Town Group petered out and it was decided to form another and more comprehensive society and to call it the London Group, Gilman was elected president. He was a dedicated teacher, too, and his evening classes, both at the Westminster and at the small school at 16 Pulteney Street, Soho, that he afterwards ran with Ginner, were attended by admirers of his painting who 'wished to learn to see colour as he saw it'. Marjorie Lilly remembered this club with gratitude. It was a welcoming place where:

Harold Gilman, *Washing in the Snow* (1909-10)
Oil on canvas, 11 × 15in (28 × 38cm). Private collection.

CHARLES GINNER: ARCHITECT TURNED PAINTER

Charles Ginner spoke perfect French, drank red wine, took a full hour for lunch and kept a mistress. He also knew about the exciting new developments in French art at first hand, having been trained in Paris. He admired the work of Gauguin, Cézanne and Van Gogh when those great painters were still being derided: 'A man who'd paint his boots can't be an artist,' said his teacher. Ginner gave up a promising career as an architect to devote himself to his art. When he came to London in 1910, he made an immediate impact. He was invited to join the Fitzroy Street gatherings and became something of an oracle to his friends, especially Gore and Gilman. A founder-member of the Camden Town Group, he was an influential writer and took a vigorous role in artistic affairs. He had a strong belief in the value of working together in friendly co-operation. The four years up to the outbreak of the First World War were the happiest of his life.

When Sickert referred to Ginner's 'burning patience' he was praising his dogged adherence to a technique which was quite individual. He built up his elaborate compositions on a foundation of accomplished drawing. After sketching in his picture faintly but carefully, he then applied a thin wash of approximately the right colour, using turpentine to dilute the paint, so that this preliminary outline dried quickly. Then he would work slowly from left to right of the canvas in strips of thick paint, like those used by Van Gogh. No one could mistake a Ginner for anything but a Ginner.

True originality, he maintained, cannot be forced; the only way for most people to acquire a personal style was to work steadily on and hope that with long experience and the constant handling of their tools, they might evolve a handwriting of their own. This sounds dull, but Ginner would retort that there are worse things than dullness. The trouble is that his plodding technique did lead to monotony. Always precise, the paintings can look stilted. The key is in the colour; when this is drab, the picture looks lifeless and mechanical, rather as if he is going through the motions. Yet even so, the spectator feels a sense of satisfaction in his perseverance; he is a marathon runner among painters.

In his finest pictures, the colour is clean, pure and in a high key. The tight construction and elaborate patterning give a highly decorative effect, rather similar to skilled needlecraft; some pictures have a 'knitted' look. Very controlled, even stately, it is an airless world with no atmosphere. Formal and studied, his work lacks a personal or 'felt' quality. In his watercolours, his drawing is accurate and fluent and he uses colour like an illustrator, to 'fill in' the shapes. Always, there is an evident pleasure in design. There is little interest in portraying people. Even in a view of a hospital ward where the patients are lying in bed

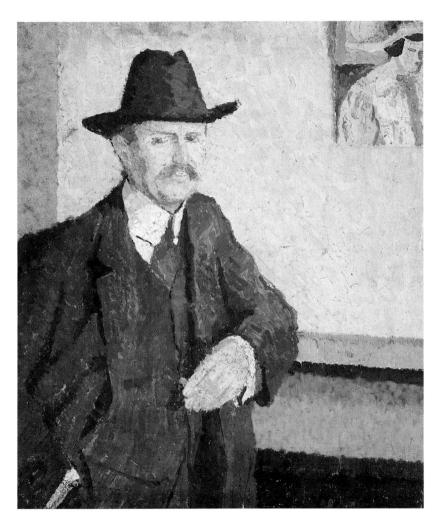

Malcolm Drummond, *Portrait of Charles Ginner* (n.d.)
Oil on fibre-board, 24 × 19in (60 × 49cm). Southampton Art Gallery.

looking despondent and the nurses move about with quiet efficiency, the effect is oddly decorative. The artist's chief concern seems to be in the rose-patterned bedspreads. These are painted with marvellous fidelity. In a view of Hampstead in the rain, he takes pleasure in the pattern made by the little figures with their umbrellas. He shows no interest in painting women. A brick wall or a tiled roof brings out the best in Ginner.

Charles Ginner, *Leeds Rooftops* (1915)
Pencil, pen, ink, 8 × 12in (20 × 31cm). Private collection.

He chose subjects well suited to his technique. These were often architectural: for instance, Leicester Square, the forecourt of Victoria Station and a long view of London Bridge. No matter how complex and difficult the subject, he is equal to the challenge. He can handle distance, recession, complicated buildings and perspective. It is an architect's painting, but curiously satisfying. Often his colour is conceptual, not observed from nature yet appealing and individual. There is a marvellous study of Leeds rooftops which has a detailed perfection. He also painted unusual interiors of factories and the circus and the occasional modest landscape of a group of farmhouses or a featureless hillside.

There is a curious parallel with Lowry, who painted by artificial light, did not marry and lived what seemed a rather empty and solitary life. Ginner had many friends, he was well-travelled and a forceful writer. Yet there is a similarity in the strange becalmed feeling in their created world. Both men were bachelors and lonely. Lowry said he painted because 'there was nothing else to do'. Ginner was far more resourceful, likeable and friendly. But as he grew older, his circle of friends contracted and he never got over the early deaths of Spencer Gore and Harold Gilman. His life was quiet and orderly. Painting in much the same way over decades may have acted as an emotional scaffolding, a comforting routine. This may help to explain the rigidity, the absence of lively people, the queer stillness.

Drummond's portrait of him was painted when Ginner was about thirty-three and had just come to London and made friends with Gilman and Gore. Disarmingly French-looking with his black moustache, he wears a stylish hat tilted at an angle. He appears happy and relaxed. Seven years later, when Marjorie Lilly met him, she took him for a bank manager or an accountant. In manner, he was quiet, composed and non-committal and he dressed conventionally. Only once did she see him throw off his reserve completely. It was at a party when he pushed aside a sofa to give himself more space, 'then executed a neat little French song and dance with complete abandon'.

Marjorie saw him as 'a thick-set, sturdy, short-necked man with a round bald head and a bun-shaped face'. Hardly a romantic Frenchman, then. When she first met him in Pulteney Street where he ran the painting school with Gilman, he was very poor but still used oil paint extravagantly. The two friends were dedicated teachers but Gilman was better with practised painters. Marjorie got into a mess trying to work with thick paint and bright colours before she was at home with more basic techniques. Ginner understood her limitations at a glance and carefully set up a more restricted palette for her. He was very kind. His understanding and steady instruction complemented Gilman's fervent enthusiasms.

Ginner formulated a creed, after long discussions with Gore and Gilman, to which all three artists subscribed. It was published in an article entitled 'Neo-Realism' in *The New Age* in January 1914 and was

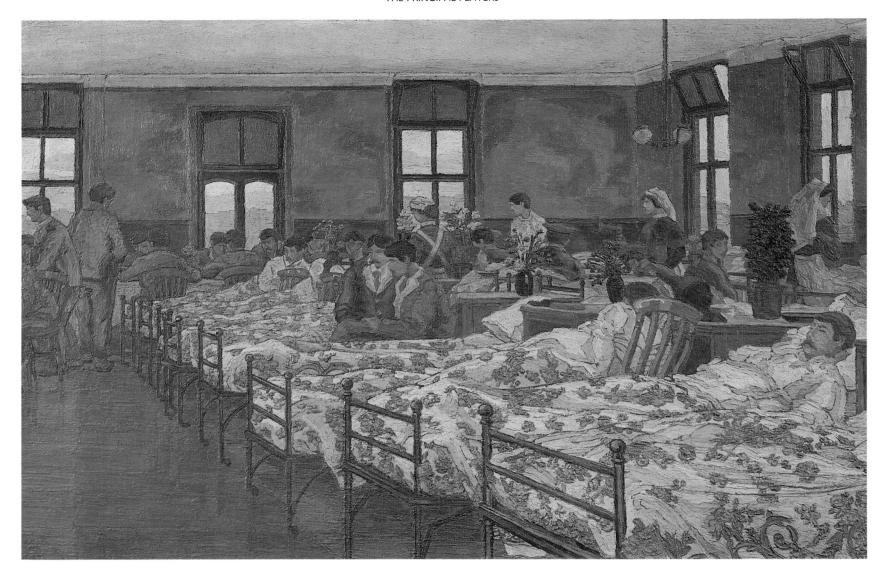

influential at that time of intense speculation about the nature of painting. Ginner's central idea was that:

> All great painters by direct intercourse with Nature have extracted from her facts which others have not observed, and interpreted them by methods which are personal and expressive of themselves … Greco, Rembrandt, Millet, Courbet, Cézanne – all the great painters of the world have known that great art can only be created out of continued intercourse with Nature.

Ginner was scathing about those 'weaker commercial painters' who

Charles Ginner, *Roberts 8, East Leeds* (1916)
Oil on canvas, 19 × 29in (48 × 73cm). Private collection.

(Opposite)
Charles Ginner, *Plymouth Pier from the Hoe* (n.d.)
Oil on canvas, 30 × 24in (76 × 61cm). Private collection.

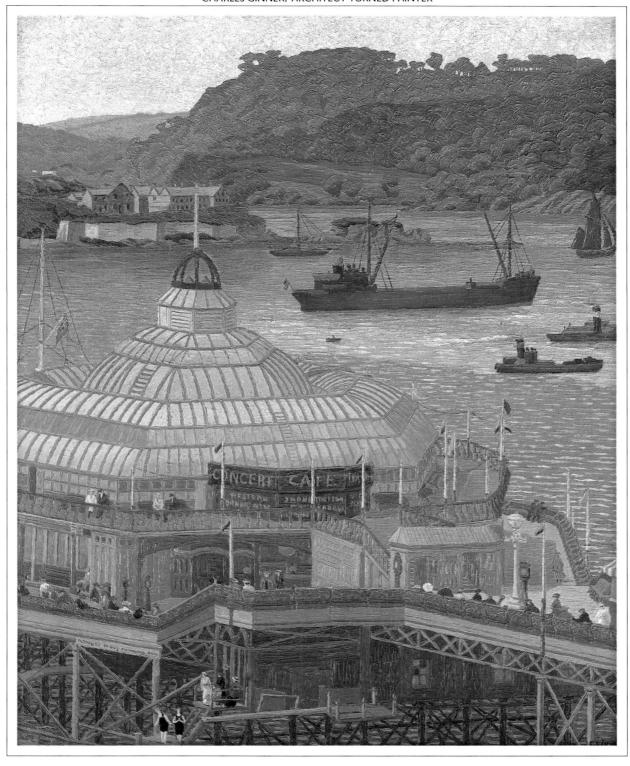

Charles Ginner, *Flask Walk, Rain* (n.d.)
Pen and black ink and watercolour, 14 × 9in (35 × 23cm). Ashmolean Museum, Oxford.

merely copied the superficial aspects of the work or the teaching of a great artist like Cézanne without putting in the hard work of observation and research. A sharp distinction was made between the individual Realism of Gauguin, who himself went to the South Seas to make his personal interpretation; and the formula created by Matisse and Co, 'to be worked quietly at home in some snug Paris studio...'

He rejected the idea that decoration is the unique aim of art, and spoke of the importance of subject to the realist:

> Each age has its landscape, its atmosphere, its cities, its people.
> Realism, loving Life, loving its Age, interprets its Epoch by
> extracting from it the very essence of all it contains of great weak,
> of beautiful or of sordid, according to the individual temperament.

Impressionism in France, he concluded, was beyond doubt the most important realistic movement, for 'the Impressionists by their searching study of light, purified the muddy palettes by exchanging colour values for tone values'. All painters needed to study the work of these great forerunners who had led the way. Ginner stressed the importance of learning from this great tradition and praised Cézanne, Gauguin and Van Gogh, 'all three children of Impressionism, learning from it as a wholesome source, all that it had to teach, and with their eyes fixed on the only true spring of Art: Life itself'.

This essay aroused considerable interest and was the subject of a long review by Sickert, again in *The New Age*, in April 1914. Ginner must have felt exhilarated by the consciousness that he was playing a full part in one of the chief artistic movements of his time and as a knowledgeable Frenchman working within an English milieu he was particularly valued.

Like all the Camden Towners, Ginner was a glutton for work. Despite the fact that he came from an artistic and musical family, Ginner had had to overcome parental opposition to his vocation as a painter. This had strengthened his resolve. He was born in Cannes and his father, who was an English physician practising on the Riviera, was a keen amateur painter. His mother sang so beautifully that Saint-Saëns composed some songs especially for her. Charles formed a close bond with his younger sister Ruby. She was a dancer and influential teacher, well known for her original method of dancing based on her interpretation of Greek art and culture. She ran a ballet school in Islington. She was also a lucid writer with independent ideas. They kept in close touch throughout their lives.

Ginner suffered a damaging disappointment early on. As a young man, he had been deeply in love with a woman who had preferred to marry someone else. Her marriage was not a success. There were two daughters, and Ginner, who was very fond of children, made himself responsible for their education and welfare. Perhaps he never recovered from his early love and this secret, in an otherwise straightforward life, may account for an habitual reticence and shyness. He affected a cynical attitude towards sex. His mistress, he explained, was a constitutional

necessity, like the red wine that he drank and his daily habit of gargling with TCP.

When he first came to London, Ginner lived with his mother in Battersea. Later, he took rooms in Chesterfield Street, by King's Cross Station in the heart of Camden Town where Gilman and Gore were neighbours. The three met constantly in one another's studios, at the Fitzroy Street Saturday afternoons and at the Café Royal for dinner as often as they could afford it. Gore's death and the outbreak of the First World War brought this happy time to a melancholy end. Ginner was called up about 1916 and, because he was completely bilingual, he was transferred to the Intelligence Corps. For a short time after leaving the army, Ginner shared a teaching studio with Gilman. In January 1919, Ginner caught influenza and Gilman went to his lodgings to help nurse him, but they both developed pneumonia. They were taken to the French hospital and put in beds side by side. Ginner made a good recovery but Gilman died on 12 February. The death of Gilman intensified the loneliness Ginner had felt after the death of Spencer Gore.

In the Second World War, Ginner served as an official artist, specialising in harbour scenes and bomb-damaged buildings in London. During the War, he moved to 66 Claverton Street in Pimlico and lived there until his death. After 1946, his health began to fail, though not his skill. Sadly, during the next six years until his death in January, 1952, he completed only six oil paintings and seven drawings. Poetry was important to him during these solitary times, and when Marjorie Lilly went to see him shortly before his death, he was doing a series of pictures in what he called his 'Wordsworth mood'. No matter how he felt, he would take his place at the big studio easel by the window. His self-portrait of 1946 shows just how he used to sit. He wore a sober suit and collar and tie for painting in – just as if he were going to work in an office.

Ginner's health had first broken down at the age of sixteen when he had contracted typhoid and double pneumonia. For almost a year, in a successful attempt to restore it, he sailed the South Atlantic and the Mediterranean in a tramp steamer belonging to an uncle. Towards the end of 1951, at the age of nearly seventy-four, he developed pneumonia again – for the fourth time. His sister Ruby was at his side and he expressed the wish that he would not recover this time, saying: 'What is the use of living if one hasn't got a life?' He died on 6 January 1952.

John Rothenstein, who was his neighbour in Pimlico, used to visit him in the two small rooms which he kept meticulously tidy. To an extent he lived in the past. His two close friends had been dead for more than thirty years, yet the vivid life that he had lived in close friendship with Gore and Gilman was still present to him. Ginner would ask Rothenstein to dine with him in the sort of 'eating-house' with shabby red plush seats which Harold Gilman had immortalised. On his return, he would settle down with a book in his quiet sitting-room adorned by half a dozen studies given to him by friends. His small library consisted

Charles Ginner, *Snow in Bloomsbury* (n.d.)
Oil on canvas, 30 × 22in (76 × 56cm). Private collection.

of a hundred or so well-thumbed classics in French and English. In the summer months, he took his annual painting holiday. He lived with the simplicity of a complete artist.

Rothenstein felt that Sickert's epithet went to the heart of his achievement and that Ginner's 'burning patience' enabled him 'to create, both in oil and pen-and-ink and watercolour, a long series of pictures which reflect the continuous growth of a personality entirely humane, honourable and modest.'

(Opposite)
Charles Ginner, *The Avon, Bath* (n.d.)
Oil on canvas, 27 × 20in (69 × 51cm). Private collection.

Charles Ginner, *The Dome, Brompton Oratory* (c. 1910)
Watercolour, pen and ink, 15 × 12in (38 × 31cm). Private collection.

ROBERT BEVAN: THE ROMANTIC HORSEMAN

A Polish girl is combing her dark hair by the window. Her brown eyes are dreamy as she thinks of her letter from England. She gazes out over her father's lands which stretch as far as the eye can see. Forests, sawmills, rivers, watermills, all belong to them. They breed their own cattle – and horses. She sighs and turns away. Suddenly, a clatter of hooves in the courtyard brings her back to the window. There is her Englishman!

Robert Bevan had crossed Europe, deep into the Polish countryside to find her. He was a daring and skilful rider. After corresponding with the girl he had loved for only a few weeks, his impatience got the better of him. He saddled his horse and rode to her father's house in Szeliwy, near Lowicz in central Poland. They were married in Warsaw on 9 December 1897. Lochinvar had won his bride.

She was Stanislawa de Karlowska and had met Robert Bevan that summer at a wedding in Jersey where she was a bridesmaid. Bevan must have declared his love for her before she returned to Poland for they corresponded – in French, the only language they had in common. Stanislawa was a painter too and was just the partner he needed to support him as an artist and to understand his preoccupations. She was charming, lively and sociable, and helped to counteract his reclusive tendency and his habit of withdrawing into himself. Their marriage was very happy. Not only was Stanislawa the best possible wife for him but Poland provided a wealth of interesting subjects for an artist of his temperament. Bevan was a romantic. Stanislawa with her gaiety and spontaneous warmth and Poland with its traditional way of life released him. A certain rigidity and conformity was part of his nature. It emerges in his cold paintings of suburban streets. His Polish pictures are quite different. Brilliant colour, a rhythmic, flowing line and an obvious delight in the work itself, shows an artist at one with his subject.

Bevan needed a primitive environment and unspoiled countryside to be at his best. He found this initially in Brittany where he worked with Gauguin. He went to Brittany for the first time in 1891 and, judging by the evidence of his drawings, he was captivated by the country and its people. Perhaps his most eloquent drawings are of the women in their distinctive Breton costume. The young girls are drawn with an exquisite tenderness, the old women with compassion and respect. Technically, these drawings are superb but it is the artist's personal response which makes them works of art in their own right.

Bevan made a second visit in 1893-94. On both occasions, he stayed at the Villa Julia, a well known centre for painters, and became a familiar

Robert Bevan, *A young woman seated.* Pencil on paper, from a sketch-book marked 'Port Aven Nov 91', 10 × 7in (26 × 17cm). Ashmolean Museum, Oxford.

figure in Pont Aven where he was known as 'the English giant'. A young man in his mid-twenties, adventurous and well travelled, he felt at home immediately and relished being part of an artists' colony. The country life with its simplicity, variety and vigorous activity was just what he liked. The unspoilt landscape and the naturalness of the hard-working people aroused an affection which lasted all his life. In a letter to his mother he writes:

> Nothing but Breton is talked among the people; most of them knowing very little French, some none at all. The spinning wheel is used here a great deal. I saw a man making a new one only the other day, and assisted in beating out some flax myself yesterday.

Gauguin was the chief influence on Bevan's work and affected him profoundly. They worked together. There are drawings in Bevan's Pont Aven sketch-books which look like Gauguin. They show a swarthy, powerful man with a moustache and glossy hair. In one sketch he smokes a cheroot; in another he is holding a pack of cards. There is a café scene in the background. Technically, Bevan was influenced by his bold patterning, brilliant colour and love of primitive subjects. Gauguin's strong personality and the stimulus of the painters who gathered round him at Pont Aven must have given Bevan just the camaraderie he needed at the outset of his career.

The drawings Bevan made in Brittany are revealing of the man and the things that interested him most. Flax-beating, sabot-making and threshing are subjects that he worked on repeatedly. Characteristically, he made studies of animals: chickens, cows, bulls, a terrier drooping on its paws. And, of course, horses, drawn from every angle. He liked to draw people at work: the women washing clothes, one scrubbing the floor with a pail beside her. Traditional costume fascinates him; there is a back view of one of the locals where his wide-brimmed hat, blouson jacket, narrow trousers and sabots are carefully drawn. Bevan was often to show this interest in what people wear and how clothes reveal personality. The Breton sketch-books show Bevan to be a masterly draughtsman. He excelled at depicting animals, especially horses; both Renoir and Sickert at different times praised this key aspect of his work.

Robert Bevan had a prosperous background. He was the son of a banker and was brought up in Cuckfield, near Brighton. Here he enjoyed a well-to-do way of life in the country. As he was growing up he must have taken a keen interest in the animal life as well as the countryside, for his later drawings of ducks, geese and oxen, for instance, show close knowledge of how these creatures behave as well as how they look. But his passion was for horses. He was a keen hunter and an intrepid rider. When he went to Tangier in 1892 to work with the artists Joseph Crawhall and G.D. Armour, he did more riding than painting and the following year he was Master of the Tangier Hunt. When his need for solitude led him to withdraw to a lonely farmhouse at Hawkridge on

Robert Bevan, *Head of a woman* (n.d.)
Pencil on paper, Ashmolean Museum, Oxford.

Exmoor, he again combined hunting with painting and drawing. This was from 1895-7 and he may have been trying to recreate the primitive way of life he had found so congenial at Pont Aven. This desire for seclusion he certainly shared with Gauguin who had again left for the South Seas.

After their marriage, the Bevans lived first in Brighton and then settled at 14 Adamson Road, Hampstead, a house with a large north-lit studio on the top floor which had been built for an artist. This was their permanent home and their two children were brought up there. Bevan's most important work in the first years of his marriage certainly stems from Poland where he worked in 1899, 1901, 1903, 1904 and 1907. During these years, Bevan developed a strong feeling for Poland and the Poles; he found there the qualities he had liked and admired so much in Brittany. And he was very much a part of the everyday life. His wife's father and brothers-in-law had substantial estates. They farmed the land themselves and knew every detail of what went on. It was a life full of varied character: always something to see and do and talk about. And for an artist, always something to draw.

When he returned to London, Bevan would work up his drawings and colour sketches into finished paintings. With every visit, he developed his subject-matter and technique. Besides animals, he drew thatched cottages, a country road, a team of horses drawing the plough. He made

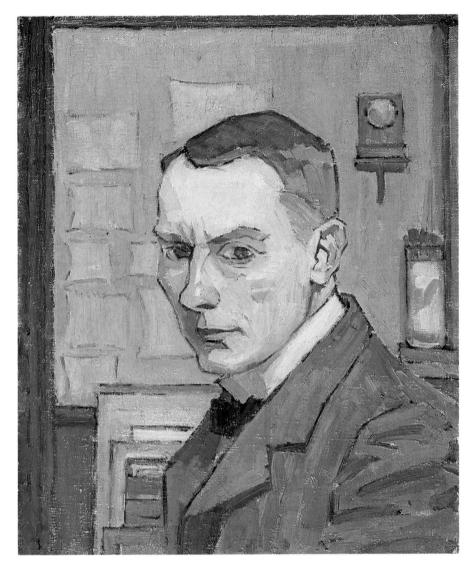

Robert Bevan, *Self-Portrait* (1913-14)
Oil on canvas, 18 × 14in (46 × 36cm). National Portrait Gallery.

studies of people at work, drawing water from the well at Mydlow, the blacksmith at his smithy in Szeliwy. Traditional dwellings set among graceful clumps of trees, a horse and rider stopping to ask the way at a lonely farmhouse were the sort of subjects he loved. As Bevan becomes more of a painter, his drawings change. Investigative sketching, rapid studies for the purpose of collecting information, explanatory notes to help him to recall the scene later all show this change of emphasis. For example, one group of limes has the comment 'pollarded' to explain their

shape. 'Grey morning' is noted and the time, 7.30am, is given on another. There are meticulous drawings of the plough, showing how each part relates to the other; many drawings of working carts with details of their axles and wheels carefully observed. Notable studies of church steeples and different kinds of carriages are research for paintings carried out later. When he draws a grazing horse now, he often gives the whole scene with the meadow and a group of trees behind. This shows that he is thinking as a painter and composing each picture.

Robert Bevan, *Dunn's Cottage* (1915)
Oil on canvas, 19 × 22in (48 × 56cm). Private collection.

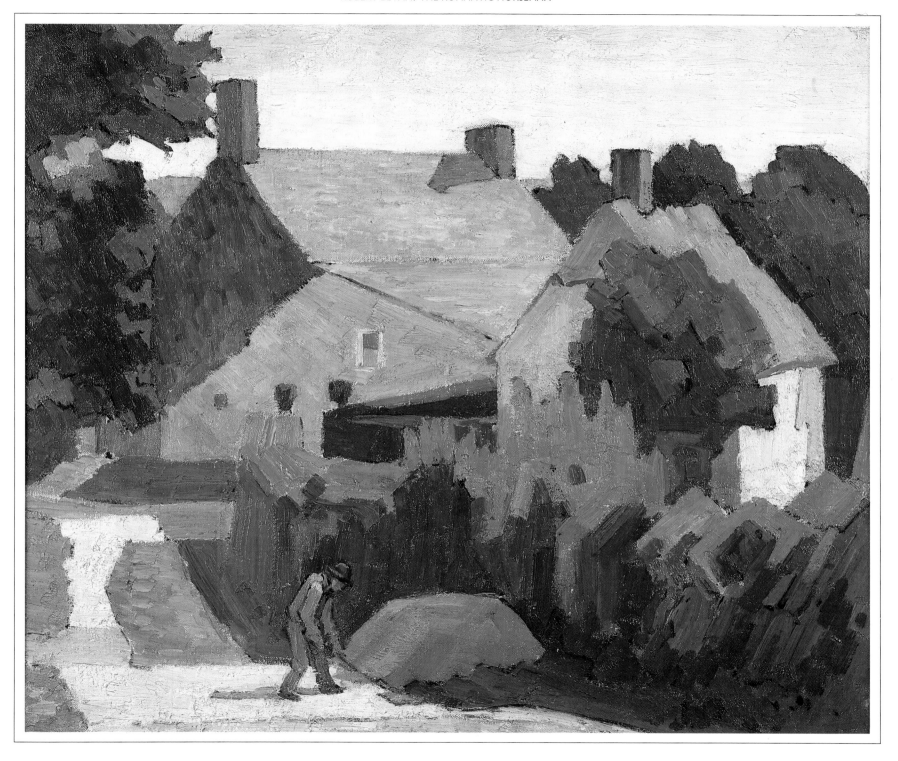

The Baillie Gallery in Bayswater held an exhibition of Bevan's Polish paintings in 1905. There were few press notices but the leading art magazine *The Studio* of September 1905 has some appreciative comments. The writer praised his 'colour and atmosphere', commenting that he 'is evidently possessed of an acute sensitiveness to the peculiar kind of effects to be seen in the country.' Bevan's response to the character of Poland is noted. The writer felt that he gave a 'very definite and valuable idea of the country... and seemed to have approached each separate subject with a new curiosity. Consequently his technique was varied and experimental, being in every case accomplished and thoughtfully adapted to the treatment of the subject in hand.'

Such encouragement was rare. By this time, Bevan was forty and had been working in isolation for ten years. He did not know where to find the sympathetic criticism or support he needed. Many pictures were burnt in the studio stove. His wife was his mainstay. She had an unquestioning confidence in him and her outspoken pride in his work was not shaken by his uncommunicativeness and long withdrawals into himself. When his son regretted the destruction of a particularly appealing picture, Bevan answered:

> Your mother, of course, thinks I am a great artist. I don't know about that, but I am sure that I could not go on without believing that I had done some good work and was capable of better. She too has always complained of the amount of work I destroy; but it is easy to exercise that kind of criticism when work is left unsold on your hands. That she has always shown such confidence has always meant a very great deal to me.

Bevan had a cottage at St Ives, Kingston, near Lewes in the South Downs. It was completely unspoiled and he retreated there to work alone during 1905 and 1906. Living a life of utter simplicity, he would chop wood, draw water, cook and generally fend for himself, wearing sabots around the house. He got up with the sun and walked long distances to draw his subjects, then came back to paint them in the bare unfurnished rooms which served as his studio. The responsibilities of a growing family did not interfere with this pattern. Ten years later, he found a cottage, Lychetts, in the Bolham Valley in the Blackdown Hills. He would go down early in May and stay till the middle of November. His wife would join him for about six weeks during the school holidays and his son and daughter would sometimes share his Spartan existence for two or three weeks at a time.

The paintings that he produced in this utter solitude were quintessentially Bevans. He painted classic studies of working horses in the dawn light. *Ploughing On The Downs* (1906-7), for example, shows his consummate skill. Three farm-horses are harnessed ready to pull the plough. Each is an individual. All three stand patiently but we can see from the position of their heads, as well as the movement of their strong frames, that each horse regards the day's work differently. One farm-worker stands ready to lead; the other bends over the plough fixing the shaft. The picture is eloquent of the relationship between man and horse as they prepare to work the land. The horse gives to man that 'free servitude that can still pierce our hearts', as Edwin Muir puts it.

Frank Rutter of the *Sunday Times* was full of praise for this picture when it was shown in 1910. He admired its 'magic of colour', 'decorative truth' and 'the beauty of its interpretation'. This was the first whole-hearted tribute to Bevan's work to appear in the London papers.

His son felt that the years of loneliness and neglect had an effect on Bevan's temperament, making him more shy and reserved and less inclined to fight the battle of selling his work. They did not destroy his courage or his power of working out problems for himself. But the lack of fellowship and recognition became difficult to bear and created strains in the family. It took all Stanislawa's vivacity to keep a cheerful atmosphere.

A better time was ahead. The decisive event was the first Allied Artists' Exhibition in 1908 where the work he showed was admired by Spencer Gore and Harold Gilman. They invited him to join the circle at Fitzroy Street, where he met Sickert who recognised his talent and encouraged him to paint what he found interesting in the everyday life around him in London. Sickert particularly admired Bevan's superb drawing of horse and cab subjects for which he became chiefly known. His originality earned him the respect of his peers. It quickly became known that he had worked with Gauguin and his circle in Brittany and had kept in touch with developments by visits to Paris. Bevan became a member of a lively and creative group of painters again; he was esteemed for his own contribution and as an important link between French and English painting. As a founder-member of the Camden Town Group he had found his niche. When this broke up, he was an original member of the London Group and went on to form the Cumberland Market Group in 1915.

Bevan threw himself into this new and stimulating life. Marjorie Lilly met him at the Fitzroy Street parties where he would take up his stance at the chimney-piece, having arranged his glass of beer and smoking apparatus on the shelf with his usual deliberation. From this position he could observe in the mirror before him every newcomer who entered the door. Bevan was no egalitarian and Fitzroy Street was full of gatecrashers looking for Bohemia. They would descend on neighbourhood parties and consume as much as possible of the food and drink before the invited guests arrived. He had more than a touch of gallantry and felt it his duty to see that Marjorie and her friends were not exploited. He had his own way of dealing with them:

> He subjected each guest to a prolonged glare, to assure himself that they were presentable. Sometimes, when he was doubtful of their respectability, he would question us loudly about them in his own

particular brand of Anglo-French, much to their joy if they happened to understand him.

Marjorie admired him as a versatile painter 'concerned chiefly when young with horses… but his landscapes, especially of Poland, were far more colourful than those of most English painters of his time'. She said that he was much appreciated as a draughtsman and for his lithographs which were another, very individual aspect of his work.

The horse-sale and cab-yard pictures for which Bevan has become principally known were mainly done within a few miles of his home in Hampstead. He made numerous drawings in preparation for his oil paintings. There are meticulous studies of parts of the horse – legs, hoofs, heads with ears pricked, confident drawings of the horse feeding from the nosebag and joyous sketches of them being groomed. Acute and well-informed observation is evident in Bevan's small sketches of men who have to do with horses – the handlers, the dealers and the crowds of horse-fanciers. He throws light on character with his sharp recognition of contrasting styles. Those who gather at Tattersall's where hunters and carriage-horses were sold differ in dress and mien from the crowds at the Barbican or Aldridge's where the trade was mostly in van-horses and hacks. With great skill, Bevan differentiates between the lithe figures of the young grooms as they lead out the horses, and the heavy, well fed bodies of the customers.

Cabs and carriages, Bevan drew with consummate ease and pleasure. He is interested in every part – graceful wheels, carriage-lamps, the curved roof – all perfectly in proportion, each fitting convincingly into the other. It seems that he was born to record this distinctive feature of Edwardian London. Full of poetry, his paintings of this subject show his acute sensitivity; he gives us the atmosphere of the twilit city, the sound of the horse's hooves on the cobbled streets, the driver in his long coat and bowler, the horse itself in all its magnificent strength and poignant submission. Yet he gave up painting hansom cabs. He told his son that he was anxious not to be accused of sentimentalising a feature of London that was fast disappearing.

His children were always very conscious of the importance of horses in their father's life. They were often allowed to go with him when he was making drawings for cab-yard and horse-sale pictures. In earlier years, he took them by horse-bus, and they sat on the front seat on top so that he could talk horses to the driver. At Tattersall's and Aldridge's, the Barbican and Ward's Repository, he would always have a word or two with dealers and with handlers – and even with the bearded, top-hatted auctioneer – who all seemed surprised that anyone should think they were worth drawing. He always looked at home in such places in his bowler hat and grey suit and enjoyed looking like a man who had more to do with horses and hounds than canvas and paint.

His self-portrait is very like him, according to his family. It was painted when he was forty-nine and he did not change much during the

Robert Bevan, *Hounds feeding* (n.d.)
Charcoal, 14 × 17in (36 × 43cm). Ashmolean Museum, Oxford.

rest of his life. He was tall and slim and Charles Ginner used to say that he looked like a countryman in the city. A certain distinction in bearing and dress earned him the nickname of 'the Prime Minister' among his daughter's friends. A stiff white collar, finished with a thick blue bow and a respectable suit were his habitual wear. Painting alone in Devon, he became seriously ill with a cancerous growth and failed to recover from a painful operation. He died in 1925 and was buried in the family grave at Cuckfield. Although he was sixty-five and had devoted his life to painting his work was hardly known outside a small circle and most of his pictures remained in the hands of his family.

Frank Rutter recognised his achievement and compared him to the great painter of horses, Stubbs. He said that if he were given free rein to show English painting at its best, he would have a Stubbs gallery and in addition, he

would devote a whole room to the paintings of Robert Bevan, so that France and the world might know that England had another great horse painter, racy of her soil, in the Twentieth century; none of your slick society horse-painters, but a real artist in the mainstream of the European tradition who kept his own particular personality clear and distinct though he lived through the stormy days of Impressionism and Post-Impressionism.

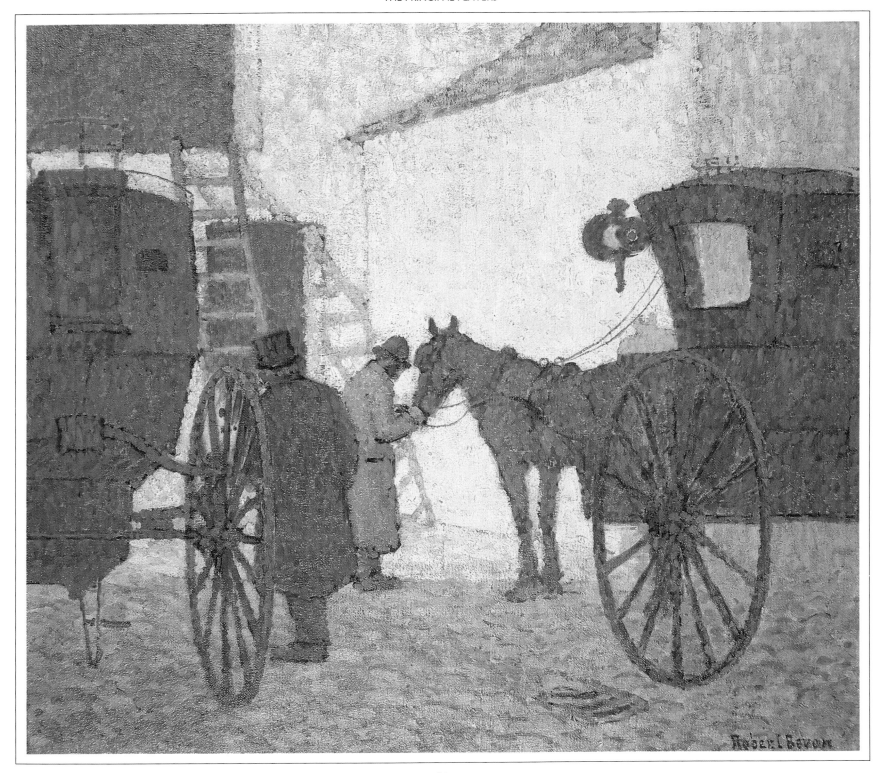

(Opposite)
Robert Bevan, *Cab Yard at Night* (c. 1910)
Oil on canvas, 24 × 27in (61 × 69cm). Royal Pavilion, Art Gallery and Museums, Brighton.

Robert Bevan, *Ploughing on the Downs* (1907)
Oil on canvas, 24 × 32in (61 × 80cm). Art Gallery, Aberdeen.

LUCIEN PISSARRO: A SIMPLE HEART

Lucien Pissarro was regarded as an authority and held in the highest esteem. As the son of the great Camille, one of the founding fathers of French Impressionism, he was a source of inspiration to his fellow painters. Sickert, who revered Camille and had been influenced by him, recognised the importance of Lucien's contribution and his unique role as part of two distinct traditions, the French and the English. He said that Lucien held 'the exceptional position at once of an original talent and the pupil of his father'. To all aspiring artists he was 'the authoritive depository of a mass of inherited knowledge and experience'. They looked to him as a guide or even ' a dictionary of theory and practice on the road we have elected to travel'.

This responsibility weighed heavily on Lucien at times. He was fully aware of his privileged background and grateful for the excellent grounding he had received. From his infancy, he had been taught to draw and paint; no artist was better prepared for his profession. Once he had left the parental home in France, his father started to address a stream of letters to him on the correct principles and practice of his calling. Lucien venerated his father but was determined to find his own identity as a painter. So he took the decisive step of moving to England, where he settled at The Brook, a Georgian farmhouse in Chiswick, in 1902.

Lucien had first come to England at the age of seven with his parents, as refugees from the Franco-Prussian war of 1870. They lived in Upper Norwood. He returned in 1883 to learn English, staying with his cousins in North London and working for a music publisher to earn a living. His love of music dated from this time, when he would regularly attend concerts. He longed to devote himself to painting but the family was suffering extreme poverty back in France and Julie, his mother, was anxious that he fit himself for a secure occupation. Lucien applied himself earnestly to his job and his studies but he still managed to paint regularly in Regent's and Finsbury Parks. After a further six years in France, Lucien came back to England permanently in 1890. He had fallen in love.

Esther Bensusan was a distant relative whom Lucien had first met when she was a child. Her father disapproved of the match so they used to meet secretly in the British Museum and go walking in Kew Gardens. They were married in 1892 and had a daughter, Orovida, who was a fine artist too. It proved to be an enduring marriage and Esther's unfailing devotion and support were indispensable to Lucien. He would write to her constantly from wherever he happened to be painting, expressing the anxieties and doubts he felt, especially about his ability to live up to his inheritance as the son of a great master.

One such letter shows his despondency and his fear that he is but a pale copy of the great Camille. To Esther, he writes:

> I am not at all satisfied with my work and I realise very much what a hopeless struggle I am engaged in – for I am not a painter, I have no side quite my own – I see very clearly that my personality is only a weak diminution of the poor dear old father… I have no facility.

He wrote this on 22 February 1910, two days after his forty-seventh birthday. He had spent years perfecting his technique and going to nature with humility and patience yet still these moods of discouragement would sweep over him.

It was as a designer and maker of books that Lucien first established his artistic independence. He had a strong interest in printing and had worked as an illustrator in Paris, though without much success. He looked to England as the country where William Morris had revived the idea of the book as a work of art and had set new standards with his Kelmscott Press. Lucien set himself to learn the craft. He became friendly with the illustrator and designer Charles Ricketts, and contributed to his elegant journal, *The Dial*. Fired with enthusiasm, and with Esther in

Lucien Pissarro, *The Church of Chaumont-en-Vexin* (1926)
Watercolour, 7 × 10in (18 × 26cm). Private collection.

Lucien Pissarro, *Le Plateau de Chaumont from Vexin* (1926)
Watercolour, 7 × 10in (18 × 26cm). Private collection.

strong support, Lucien founded the Eragny Press in 1894. It was named after the small village in Normandy where Camille had set up the family home. As a designer and maker of books, Lucien's exquisite colour and overall harmony of design was his most remarkable accomplishment. He worked on every part, designed and cut the type, engraved the illustrations and made the bindings. Christine Sickert described one of his books as 'charm and beauty made tangible and everything about it... so delightful in design and colour'.

Another way in which Lucien differed from his father was in his commitment to watercolour. His watercolours are small in scale, painted on the spot, and they show his fine drawing, sensitive response and refined colour. Lucien developed an individual approach to this demanding medium. He used a mixture of pencil, black ink, crayon and washes of colour. This combination gives substance and texture to his work. In oil and watercolour, Lucien was principally a landscape artist. He was able to convey the character of a place and his work is strongly designed while still keeping the freshness of a sketch. He knew

(Below)
Lucien Pissarro, *The Mill, Blackpool Vale, South Devon* (c.1913)
Watercolour, 12½ × 9in (32 × 22cm). Private collection.

(Above)
Lucien Pissarro, *Youlgrave, Derbyshire* (1928)
Oil on canvas, 14 × 10in (36 × 25.4cm). Private collection.

(Opposite)
Lucien Pissarro, *'The Hamlet' of Hewoot, Somerset* (n.d.)
Oil on canvas, 18 × 21in (46 × 53cm). Private collection.

Lucien Pissarro, *View of Colchester from Sheepen Hill* (1911)
Oil on canvas, 21 × 25in (54 × 64cm). Colchester and Essex Museum.

Lucien Pissarro, *Under the Pines, Kew, Sun* (1920)
Oil on canvas, 17 × 21in (43 × 53cm). Private collection.

instinctively the kind of subject which suited his delicate and gentle approach. 'I only like little corners which compose harmoniously', he wrote. He found these in out-of-the-way places by the rivers, among the hills and in the villages of both France and England.

Rural scenes – a little group of houses shaded by trees, for example, or a traditional building such as a church or a mill, a quiet spot along the Seine or the Thames with a boat lapped by the water – were his kind of subject. He was fascinated by the juxtaposition of landscape and architecture and enjoyed the different shapes of roofs, towers, spires, buttresses and simple cottages whether he was painting in Epping or Eragny. In England, he moved around the West Country, along the south coast, through Surrey, Hertfordshire, Essex and Suffolk as well as working in South Wales. Some favourite spots were Rye, Lymington, East Knoyle and Lyme Regis. In France, he painted in the area around Dieppe and Le Havre as far down as Le Frette, north of Paris. He worked in the South of France, too, for instance in the countryside around Bandol and Toulon. Wherever he was, he selected gentle scenes showing the presence of a community by public buildings, farmhouses or small dwellings. His was an intimate and delicate vision and his tranquil and conscientious temperament is somehow mirrored in his work. Since he found his style – a highly accomplished, luminous Impressionism, early on, his painting changed little.

Lucien wrote to Esther from wherever he happened to be painting. The weather, the midges, the embarrassment of being stared at by curious onlookers were regular themes. Being able to write to Esther about his frustrations obviously meant a great deal to him and she understood his written English. Although he spoke the language well, Lucien never completely mastered the written word and his letters have some amusing slips. In one he wrote, 'The weather is very fine just now – and I am working hard…but the summer is frightfully hot… and when the cool of the evening arrived one is simply devored by the migget! as for files – they are terrible!!'

Sometimes, he regretted his decision to settle in England with its Philistine attitude to painting. Back in France and working among the traditional haunts of Impressionism, he wrote: 'the real thing is that I have done the stupidest thing of settling in the less artistic country of the whole world'. His shyness comes out in his letters. From Hastings he wrote on 29 January 1918:

I have finished my morning picture from my window – I have sketched a small one in the afternoon on the West Hill, I found a place between trees where I am not too conspicuous – I thought I would only start a small one, as I feel rather shy it is such a big town, with people walking about everywhere – but so far they have not detected me between my trunk of trees.

Working out of doors in all weathers was fraught with problems but

he was rewarded by sights of surpassing beauty. As a superb colourist, he was entranced by the loveliness of autumn. From East Knoyle in Wiltshire, where he worked during 1916, he wrote in October: 'The work is getting better I begin to be happier the place is lovely with the trees getting yellower every day & the weather though very changeable is tolerably fine tho' chilly'. As the days grew colder and the November gales began, he writes: 'I try my best to work but the weather drive me mad – the wind mercilessly blows away every day more and more my lovely purple leaves'. His patience, humility before nature and dogged endurance were heroic.

Painting was a vocation to Lucien; he had the highest ideals and standards and he was sought after for his keen judgement and fine discrimination. When Frank Rutter founded the Allied Artists Association in 1908, he consulted Lucien who agreed to be on the hanging committee. He was a founder-member of the Camden Town Group and his sensitive understanding of colour and inspired handling of paint were an important influence, particularly on Spencer Gore. Lucien was careful about the company he kept. He did not have Gore's inclusive attitude and objected to experimental work being hung alongside his own. In a sharp letter to Spencer Gore, he complained about Wyndham Lewis's whirling, aggressive style, saying: 'I am quite upset by what I saw this afternoon at the Camden Town exhibition. The pictures of Lewis are quite impossible' (December 1911).

He took an active part in the artistic life of his time. As well as exhibiting in all three Camden Town exhibitions, Lucien was a member of the New English Art Club. He joined in 1906 and showed work with them virtually every year for the rest of his life. He was invited to give a lecture on Impressionism and overcame his considerable reserve to do so. Writing to Camille, he said:

> My talk, which I made very short and entirely historical, carefully avoiding personalities but all the same explaining that Impressionism is not Realism... and mentioning the division of tones and all that in general constitutes a painter of the school, had a certain success. It will astonish you that I, the timid one, accepted to do such a thing but you could not have been more astonished than me.

Through this address, which took place in May 1891, Lucien met many artists including Sickert (who became a close friend) and Wilson Steer. Lucien thought that Sickert's studio was 'deplorable' but was impressed by Wilson Steer, describing him as 'very intelligent, he is an artist, at last!' No matter whom he met or which society he joined, nothing deflected Lucien from the principles and practice of Impressionism. He used always the finest materials, getting his canvas and pigments from the best dealers, painting out of doors in every kind of light and never varnishing his pictures. Such conviction made him an oracle. He

Lucien Pissarro, *Big Ben from the Thames* (c. 1914)
Watercolour, 8 × 10in (20 × 26cm). Private collection.

would never consent to give formal teaching, but he used to invite serious students who approached him to bring their work to his studio. His quick and accurate discernment of their needs and quiet modest manner spread his influence among a wide circle of younger artists.

Lucien had an ideal of painting inherited from his father. He believed that all serious painters went to nature where they followed and obeyed 'la sensation' – their direct feelings when faced with each new scene. No theory or fashion was allowed to influence them at this moment of truth. What they saw and their personal response to it was all that mattered. Spontaneity and honesty before what nature gave resulted in pure and vital work. The test of a masterly painter was his ability to organise his sensations; that is, to continue working in the same frame of mind. Such an approach is both rigorous and fraught with difficulties especially for a painter working in England. The changeable weather and varying light was always a problem. Lucien's dedication and fortitude were prodigious and he was rewarded by his success in achieving his aim. That was to become so absorbed in what he was painting that he became unconscious of the actual handling of the tools. 'The expression of the feeling caused by the object' is what is conveyed to the viewer. The picture therefore becomes a shared experience. We see and feel something of what the artist perceived and felt; and share in his pleasure.

Lucien and Esther became part of a lively and talented circle of painters. They entertained on the second and fourth Sundays of each

month, when a fair number were invited to tea at The Brook and a smaller company of close friends stayed on for supper. These evenings were hospitable but studious with serious music and talk and examination of his excellent collection of prints and illustrated books. He was a grave character with his short stout figure, full white beard and thick spectacles. He used to wear a cloak and a wide-brimmed black hat and wherever he went he was greeted with respect and affection. He and Esther were a devoted couple and shared a love of the countryside; even in old age they would travel far afield in search of interesting sites. Their nephew, John Bensusan Butt, describes his eccentric aunt who was an enthusiastic driver:

> Somehow she managed to run a solid-tyred Ford car in France for which parts had to come from England and an antique Fiat in England for which parts had to be sent from France. Both were open cars, and it was perhaps the finest sight this devoted pair provided: Esther, short, bull-necked and rotund, at the wheel and Lucien well wrapped up in tweed cap and overcoat with his great Father Christmas beard sitting beside her. A back seat passenger, crammed in with the impedimenta of travel, when Esther stalled the engine on mountain roads, had always to be ready to leap out and prop the back wheels with rocks, carried for the purpose.

Lucien felt quite at home in England as time went on and became a British citizen in 1916. Three years later he formed his own painting

Lucien Pissarro, *Poulfenc à Riec* (1910)
Oil on canvas, 21 × 25in (54 × 65cm). Ashmolean Museum, Oxford.

circle, the Monarro Group – so named as a homage to Monet and Camille Pissarro. He died in Somerset in 1944. Tributes flowed in and the warmest and most knowledgeable were from Frank Rutter who called him 'the most learned and accomplished luminist painter working in England'. He was recognised as a master of colour in landscape and Rutter praised this aspect of his art: 'French though he may be in origin, nobody has mirrored so beautifully and truthfully the sunlit aspects of our English countryside. If we know his work well we can hardly travel through rural England in summer without being reminded of his pictures'. Sickert put him in a wider context when he wrote: 'To study the work of Pissarro is to see that the best traditions were being quietly carried on by a man essentially painter and poet'.

Lucien Pissarro, *The Glen, Kew Gardens* (1920)
Watercolour, 7 × 9½in (18 × 24cm). Private collection.

MALCOLM DRUMMOND: THE GAUDY SCHOLAR

Malcolm Drummond was an enthusiastic member of the Camden Town Group, a close friend of Gore, Gilman and Ginner and an apt pupil of Sickert. So committed was he to the Master's approach that he used to copy his sayings into a notebook and adopted his technique of making numerous studies in preparation for the deliberate building-up of a composition. Sickert and he were always on good terms. They had much in common and were both highly educated and widely read. Drummond too was a prolific writer and contributed a regular column to *The Scotsman* on a variety of themes – an activity which brought him quite a fan mail. Yet Drummond had a quality all his own; an independence of mind which showed itself in his individual choice of subject-matter.

Drummond painted some scenes that you would think were unpaintable and that few other painters found worthy of attention: the interior of Chelsea Public Library, for example, and of Brompton Oratory and the Law Courts. Perhaps his most memorable image is of the enormous dance-hall at Hammersmith. His treatment of such difficult subjects is intriguing. He uses colour emotionally to convey mood and atmosphere. By using vivid, often non-naturalistic colour he gives a romantic, rather gaudy feel to the dance-hall where the couples foxtrot sedately round the polished floor, wrapped in a world more exciting than the one outside. His subjects reflect his wide interests. He was passionate about music and painted scenes of his first wife playing the piano. A staunch Catholic, he received many important commissions from the Church, for instance for fourteen paintings of The Stations of the Cross for the Church of the Holy Name at Birkenhead.

A glutton for education, he spent three years, from 1899-1903, at Christ Church, Oxford, graduating in History, then a further four years until 1907 at the Slade School, rounding off his training as a painter in 1908 with a year at the Westminster School of Art under Sickert. Presumably his family were both prosperous and sympathetic as they seem to have supported him throughout this leisurely apprenticeship, even when he was married with three children. He married Zina Lilias Ogilvie, a Scot, in 1906 and they had a son and two daughters. His wife was a fine artist too and did woodcuts and book illustrations as well as painting. Two of her portraits were accepted by the Royal Academy. Her approach was the opposite of her husband: while he was a slow and deliberate worker, she had a flair for the quick and spontaneous. Yet they worked in harmony for years in their Chelsea studio, sharing a love of music and a gentle humorous outlook. They were both friendly with the Sickerts and there is a drawing of Zina by Sickert done in 1912 which shows a small figure in a long skirt with a thick dark plait down her back.

Drummond was one of the first to enrol at Sickert's etching class at

Malcolm Drummond, *In the Cinema* (c. 1912-13)
Oil on canvas, 27 × 27in (69 × 69cm). Ferens Art Gallery, Hull.

Rowlandson House in 1909, and began frequenting his Saturday afternoon 'At Homes'. A founder member of the Camden Town Group, he exhibited in all three Group exhibitions at the Carfax Gallery with modest price tags of between £10 and £20 attached to his paintings. His work was sufficiently arresting to provoke a reviewer into complaining against 'four blatant London subjects by Mr M.C. Drummond which irritate by the empty glare of their gaudy tints'. When the Camden Town Group disbanded and grew into the London Group, he was a loyal member and the Treasurer in 1921.

During the First World War, he worked in munitions and then in the War Office where his fluent German made him valuable as a translator. Towards the end of the War, he took a studio in the Kings Road, in which he was to paint his best-known pictures.

Malcolm Drummond, *Chelsea, Public Library* (1920)
Oil on canvas, 30 × 22in (76 × 56cm). Private collection.

On his release from the strains of the war years when he had been unable to paint, Drummond's creativity burst into new life and in 1920 he did his most original work in the distinctive personal style which is instantly recognisable. He painted the fairground, court scenes at the Old Bailey, Hammersmith Palais de Danse and London street scenes as if he had never seen them before. He is interested in people as they enjoy the cinema, dance, read in the library or listen to the judge summing up. It is the interest of an artist who touches life at many points and wants to show it his own way. Aesthetically speaking, he is concerned with the

Malcolm Drummond, *19 Fitzroy Street* (c.1913-14)
Oil on canvas, 28 × 20in (71 × 51cm). Laing Art Gallery and Museum, Newcastle.

Malcolm Drummond, *Court Scene* (1920)
Oil on canvas, 18 × 16in (46 × 41cm). University of Hull Art Gallery.

shapes and contours of figures as they relate to what is going on around them. 'People doing something, somewhere' as Sickert used to say. His colour is in the highest key, used with pleasure and confidence. Frank Rutter commented that 'his strongly personal interiors give a shock of novelty'. And he praised his 'grasp of form and keen sense of full colour'.

Drummond was never famous. He never had a one-man show and he died obscure and forgotten, save by a few friends and fellow artists. When his wife died in 1931, he decided to leave London and settled in Moulsford, Berkshire, where he devoted himself entirely to his painting. Three years later, he married Margaret Triquet Browning, an old friend from his school days. In his last few years he suffered the worst affliction possible for a painter. He became totally blind in 1942 and died three years later.

THE REST OF THE COMPANY

THE MINOR PLAYERS

WALTER BAYES

Walter Bayes was regarded as an intellectual by his fellow painters. A founder-member of the Camden Town Group, he frequented the Fitzroy Street gatherings and formed a close friendship with Sickert. Perhaps because they were both prolific writers, there was a particular bond between them. They would have 'interminable discussions' about the theory and practice of painting though Bayes was never sure of Sickert's true opinion. 'I read your *Athenaeum* article,' Sickert would say, 'read it three times and I believe, I am proud to believe, that I understood it.' Bayes took this as a tribute, but he knew that Sickert enjoyed poking fun at anyone who wrote about painting and his jibe, 'Walter Bayes / Always says' was surely in its brevity 'the most devastating demolition of a critic ever devised'. Though he smarted a little, Bayes was proud to consider himself as Sickert's protégé.

Walter Bayes came from a family of artists, and despite the fact that his training was unusual – he studied mainly at evening classes and briefly full-time at the Westminster School c. 1902 – he had a successful career in the art world. Besides being the art critic of *The Athenaeum* from 1906-16, he was a dedicated teacher and exhibited widely, holding several one-man shows throughout his long life. He held many teaching posts and was appointed Principal of the Westminster School of Art on Sickert's recommendation. He held this post from 1918-34. He seems to have been able to write and teach without losing his life-long commitment to his own work.

Although he exhibited with them, Bayes differed from the typical Camden Towners in his choice of subjects and his technique. He had little interest in urban scenes or dingy interiors and disliked the thick impasto used by Ginner and Gilman. He had an academic approach in the sense that his pictures are carefully composed and finely painted. Sometimes, his viewpoint is unusual. For example, when he painted the Russian ballet, he showed the dancers off-stage, coming down the spiral staircase. His work was widely admired. One reason may be that he showed people enjoying themselves, on the wide beaches of Brittany or under the hot sun of Provence. When he paints his wife resting on the bed, she looks natural and relaxed, leafing through a magazine with a cup of tea beside her. These were pictures to live with; there is nothing to

(Opposite)
William Ratcliffe, *Manor Farm, Norton* (c.1917)
Oil on canvas, 24 × 30in (61 × 76cm). Letchworth Museum and Art Gallery.

Walter Bayes, *Backstage at the Russian Ballet* (1918)
Oil on canvas, 27 × 21in (69 × 53cm). Private collection.

shock as there would be in a bedroom scene by Sickert. The woman is attractively dressed as well as accurately drawn. Sickert praised his work and admired his way of managing his talent, though as usual Sickert's comment is ambivalent: 'Mr Bayes is a hardened veteran, triply grizzled in the service of written criticism, of teaching, which is constructive criticism and of the severest of all criticism, the self-criticism of the laborious painter.'

PERCY WYNDHAM LEWIS

Wyndham Lewis was a quarrelsome, aggressive, restless iconoclast. A venomous wasp busily stinging whatever and whoever went against his current idea of art and truth, he made many enemies. He was a powerful and prolific writer as well as a highly original painter. As a literary and visual artist, he was always at the edge of what was new yet detached and independent. He had a strong sense of his own vocation as a critic come to satirise everyone who crossed his path, whether friend or foe; and he poured scorn on every shade of received opinion. Suspicious, challenging and secretive, his art was equally baffling and severe. John Rothenstein, who was one of the few friends who kept in touch with him throughout his life, described him as being 'harsh and isolated as a new machine in a field'.

His father was American and his mother British and he was probably born on the family yacht off Amhurst, Nova Scotia. He studied at the Slade School from 1898-1901, where he became friendly with Spencer Gore. He was a fine draughtsman. His drawings are academic in their precision and elegance. After the Slade School, he spent the next seven years on the Continent, working in Munich and Madrid and in Paris with Augustus John. Most of his early work is lost and, because of his secrecy, little is known about his background or his years abroad. Rothenstein believes, however, that his idiosyncratic views on life were formed during the course of his travels when he questioned the philosophy and character of every place and group of people he came across. He returned to England in 1909 and from then on he published widely, stories, essays, novels and plays which were all closely connected with his art.

He became an important figure in the English avant-garde, but always stood alone. Despising all criticism save his own, he created several hard-hitting but short-lived periodicals, such as *Blast* in 1914, in order to advertise his opinions. Early on he clashed with the gifted and influential critic, Roger Fry. Fry was the leader of the most powerful clique of the day, the Bloomsbury Group. From then on, he was traduced and ignored by the Bloomsburys who had the last word on artistic matters. 'By a sneer of hatred or by a sly Bloomsbury *sniff*', they did their malevolent worst with Wyndham Lewis. He delighted in the persecution, provoking and instigating the most ferocious censure.

His art is strange, original and often repellent. Increasingly abstract and machine-like, his figures resemble automata. He would depict men and women as rock-like creatures, massive, primitive and barely human, set against a landscape which is featureless yet threatening. He wanted to

Percy Wyndham Lewis, *Architect with Green Tie* (1909)
Pen, ink and gouache, 10 × 5in (24 × 13cm). Metropolitan Museum of Art, NY.

Percy Wyndham Lewis, *Portrait of Edith Sitwell* (1923-35)
Oil on canvas, 35 × 45in (87 × 112cm). Tate Gallery.

reduce nature to something rigid, tense and impersonal, stressing the multi-faceted surfaces of what he painted. 'Give me the *outside* of things,' he wrote. 'I am a fanatic for the externality of things.' His portraits can be arresting. When his style suits something in the personality of the sitter, he brings off something wholly original and timeless. This is the case in his portrait of the eccentric poet, Edith Sitwell. She has the complexity and inscrutability to match his vision and the result is a masterpiece.

Lewis joined the Camden Town Group because of his friendship with the President, Spencer Gore, and because he felt that they constituted the most serious and active nucleus of painters in London. He did not share their outlook nor was he interested in the everyday, realistic subject-matter which inspired them. His work is not in keeping with theirs and looks out of place, though his integrity as an artist was never in doubt. As Sickert put it, 'An artist can only speak as he finds... and Mr Wyndham Lewis's romantic steel cylinders filled with cannon-balls and fitted with a central grill, are, I note with relief, entitled *women*.' Sickert looked first for the sincerity of an artist and Lewis's blazing conviction is

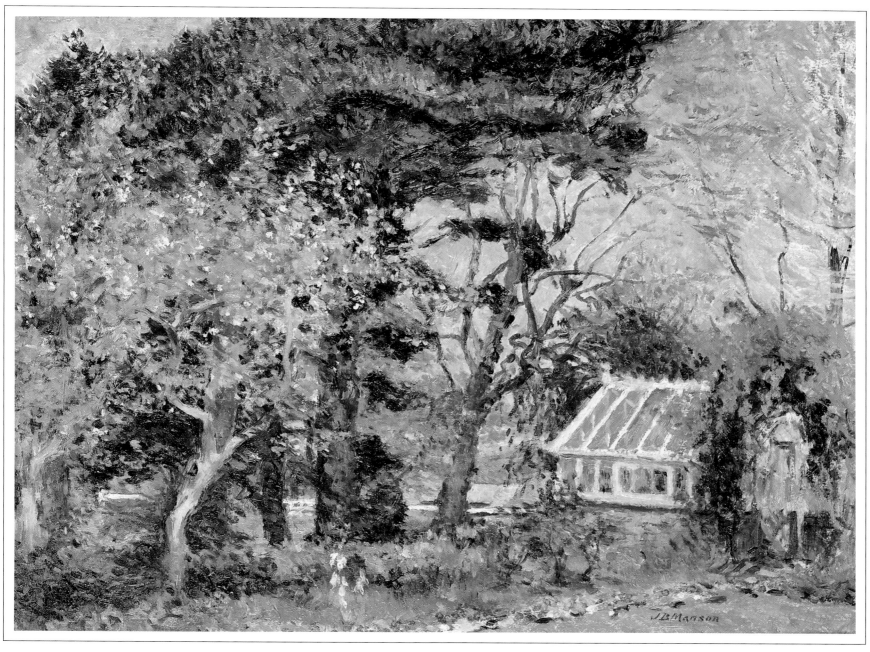

(Oposite)
James Bolivar Manson, *Marigolds in a White Vase* (n.d.)
Oil on canvas, 20 × 16in (50 × 40cm). Private collection.

James Bolivar Manson, *Spring in Sussex* (n.d.)
Oil on canvas, 14 × 17in (36 × 43cm). Private collection.

obvious even though the work itself was baffling. It was perhaps his obscurity which struck a chord with the great poet T.S. Eliot, who said of him, 'Mr Lewis is a magician who compels our interest in himself; he is the most fascinating personality of our time... In the work of Mr Lewis we recognise the thought of the modern and the energy of the caveman.'

JAMES BOLIVAR MASON

James Bolivar Manson, writer, painter, lecturer and Director of the Tate Gallery, was gifted and charming, the life and soul of the party when he felt at home in it. But he was subject to fits of depression due to the fact that he was a born painter with no time to paint. At official functions, he made no effort to conceal his boredom and impatience. Oppressed by the solemnity, he would become flippant. When he felt especially reckless, he would sing about 'A Bird in a Gilded Cage', a Victorian ditty which delighted him as it summed up his own predicament. He longed to escape from the bureaucracy and spend his time painting in the sunny climate and relaxed atmosphere which had inspired his great heroes, the French Impressionists. The great good fortune of his artistic life was his close friendship with Lucien Pissarro, who drew him into the Fitzroy Street circle. He became the secretary of the Camden Town Group and thrived on the stimulus and the opportunity of working with other serious artists.

Manson's subjects were landscapes, preferably painted under a hot sun; he especially loved the south of France and he also painted portraits and garden subjects. He was a fine colourist and had a gentle luminous style deeply influenced by the Impressionists. He would soak up Lucien Pissarro's talk of their theory and practice; they would go on painting trips together and work from the same motif. They met at a concert in 1910. Manson's wife Lilian was a violinist and Director of Music at the North London Collegiate for girls and both Lucien and Esther were devoted to music. The two families joined forces, going on holiday to such places as Rye in Kent and Fishpool in Dorset. Manson would become animated and at ease in this setting, sharing childish jokes with Lucien and painting out of doors in fine weather. Then, it was back to hateful London again with its grime, noise, officialdom and countless distractions from painting. Some of the distraction he brought on himself. He gave up much of his precious time in the evening to helping young painters and writing art criticism. Despite his heavy commitment at the Tate, Manson exhibited regularly and had three solo exhibitions. He resigned as Director in 1938, intending to devote himself entirely to painting, but his last years were dogged by illness and shortage of money. He died of a heart attack on 3 July 1945 at his Chelsea studio.

DUNCAN GRANT

If a talented painter is continually cried up as a genius by the most powerful clique in the land, what is likely to be the effect on his art? It is probably diminished. This is what happened to Duncan Grant. He became the darling and the court painter of the Bloomsbury Group who were as vociferous in praise of their favourites as they were malevolent towards their victims. Grant was cosseted deep in the bosom of Bloomsbury. He might well have become a greater painter had he broken free. Having no inclination to do so, his reputation was assured over a long lifetime. Sickert described him as 'a grand young man'. Over the years, he became 'the monarch of the longest standing in England'. Because he was modest, charming and never involved himself in art politics, he was the perfect 'type' of the natural painter for Bloomsbury's adulation. Sickert admired much of Grant's enormous and uneven output but he may have been hinting at the dangers of too easy a passage when he said that 'Duncan conquered, he saw, he came'.

Duncan Grant studied (1902-1905) at the Westminster School, which was notable for its emphasis on painting; drawing was the main activity at the Slade School. He painted for a year in Paris in 1907, where his tutor was Sickert's friend and patron, Jacques-Emil Blanche. His father had intended him for an army career and he was forced to spend much of his school time studying mathematics, of which he understood nothing. While his parents were abroad, he lived with his cousins the Stracheys, and it was through the discernment of Lady Strachey that he was able to fulfil his ambition to become an artist. She saw that he was gifted and persuaded his family to allow him to go to art school. Duncan was profoundly grateful and he and Lytton Strachey became lifelong friends. It was through this connection that Duncan was later established, with Lytton, as a prominent member of the Bloomsbury Group.

The events which most inspired Grant and gave him his direction were the Post-Impressionist exhibitions of 1910 and 1912, organised by Roger Fry. The exciting modern work by Matisse, Cézanne and Derain had a profound and long-lasting impact on him. Their inspiration helped to turn him into a fine colourist and strengthened his talent for design. Another important influence on his development was the work he did for the Omega Workshops. Roger Fry was the moving spirit behind this enterprise, too. He created it to enable artists to make a living by applied art. They designed furniture, pottery and textiles with a 'handmade' look rather than the smooth mechanical finish which Fry detested. Grant's participation in the Omega project was fruitful. He had a flair for decoration and pattern-making and later designed costumes and scenery for the theatre, showing a richly inventive imagination with a touch of fantasy.

His strengths as a painter were rich and individual colour, a fluid

handling of paint, simplicity of design and a strong decorative element. His subjects were principally drawn from his everyday surroundings, including portraits of the people with whom he shared his life. Much of his life was spent at Charleston, a beautiful country house near the village of Firle. Here he painted interiors, flower studies, garden scenes, nudes and portraits. The values that he shared with his Bloomsbury intimates, especially Roger Fry, Strachey and Vanessa Bell, were reflected in his work. They celebrated friendship and the delights of a civilised and humane way of life. Many of Grant's portraits show both sensitivity and insight. Perhaps his finest is of Vanessa Bell. She was his lifelong companion and another painter. They shared a studio, often working from the same model, and her talent stimulated him to fresh achievements.

Always a Bloomsbury artist, Duncan Grant took a very small part in the affairs of the Camden Town Group and only became a member in the autumn of 1911 after the death of M.G. Lightfoot. He exhibited one picture of tulips with them in December 1911. He preferred to show his work at Vanessa Bell's Friday Club. A dedicated artist, painting always came first with him and he worked steadily over a long lifetime. Despite his considerable achievement, there seems to be some vital element missing – a lack of urgency or passion, a sense that the painting comes about because of some inner compulsion. Some of his pictures are amateurish and facile as if he is merely going through the motions. Grant was modest about his considerable and varied gifts and never became complacent. In describing his approach he said:

I begin to paint as soon as I possibly can. It's not only that painting is such a delight, but as I paint with difficulty I want to come to grips with it with the least delay.

I usually have several pictures going at the same time – too many I'm inclined to think – sometimes compositions, at others realistic works. I don't often work on pictures of both kinds at the same time: my interest in imaginative works and in realistic ones runs in phases...

Duncan Grant died at the age of ninety-three, happy that he had spent a lifetime as a painter. Over-praised, perhaps, during his own time, he is now recognised as an artist with a singular sense of beauty and a period charm whose decorative qualities give his best work a particular appeal.

Duncan Grant, *Portrait of Vanesssa Bell* (1942)
Oil on canvas, 40 × 24in (101 × 61cm). Tate Gallery.

Duncan Grant, *Tulips* (1911)
Oil on canvas, 52 × 49in (130 × 122cm). Southampton Art Gallery.

JOHN DOMAN TURNER

Turner is remembered because he was the pupil of Spencer Gore, who taught him to draw by means of a series of letters. He was deaf and he used to send his drawings to be criticised, paying five shillings per lesson for Gore's lucid and thoughtful statements. Gore would instruct him to 'draw for a purpose and trust your eyes'. He emphasised that 'drawing is an explanation of an observation. If you observe nothing special then your drawings will have nothing to them'. Painting has to be learnt by observation, by going to nature, and all the great artists of every age 'went to nature like children to find new beauty'. Turner was not always an apt pupil and on one occasion Gore rebuked him, saying that he occasionally felt that the teacher was putting in more effort than the pupil.

John Doman Turner was a stockbroker's clerk, probably introduced to Gore by Frank Rutter. He was Gore's pupil from 1908-13. He exhibited with the Allied Artists' Association in 1911 and with the Camden Town Group, of which he was a member showing landscapes in soft pencil, chalk and watercolour. His interest in painting seems to have waned after Gore's death in 1914.

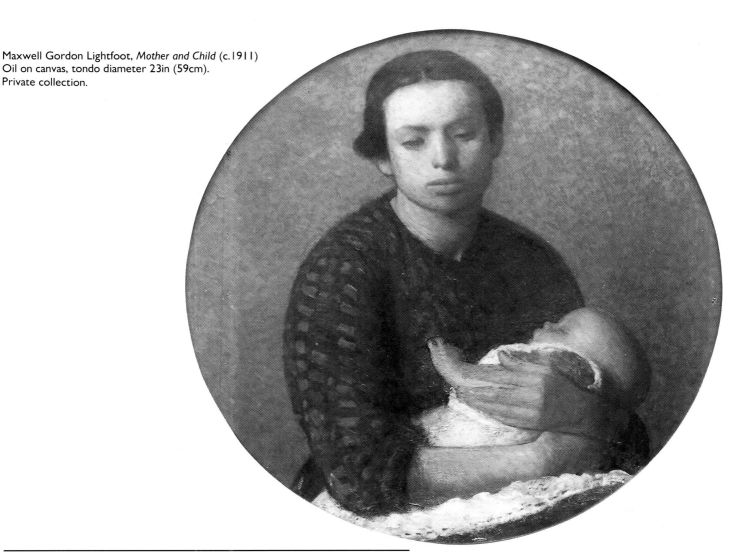

Maxwell Gordon Lightfoot, *Mother and Child* (c.1911)
Oil on canvas, tondo diameter 23in (59cm).
Private collection.

MAXWELL GORDON LIGHTFOOT

Although Lightfoot was only twenty-five when he exhibited in the first Camden Town Group exhibition, he made a strong impact. He showed two pictures: a tondo, *Mother and Child* and the portrait of a boy, *Frank*, both superbly drawn and finely painted – academic in the best sense. The critics compared him to Holbein and commented on 'this most striking revelation of budding talent'. His painting was much admired by the other members of the Group, especially Spencer Gore who introduced him into the Fitzroy Street circle. Despite this warm welcome, Lightfoot felt uneasy; believing that his traditional approach was not in keeping with theirs, he resigned after the first exhibition.

Maxwell Gordon Lightfoot was born in Liverpool and studied at Chester Art School from 1901-2, and then attended evening classes at the Sandon Studios in Liverpool. His precise drawing and flair for colour led to an apprenticeship as a commercial artist and he became particularly skilful in flower studies, designing seed catalogues and book jackets. From 1907-9, he attended the Slade School where he was recognised as a brilliant student and won many prizes. It was at the Slade that his nervous disposition began to be noticeable. Shy, austere and romantic, his drawings had great tenderness and simplicity and he was obsessed with the mother and child theme. In 1911, he became engaged to an artist's model. On 28 September they were going to Liverpool to meet his family who had serious doubts about the marriage. The night before, in a mood of acute anxiety and nervous tension, Lightfoot destroyed all the work in his studio and committed suicide.

HENRY LAMB

Lamb drew like a master but rarely achieved a personal interpretation in his painting. He was a weak character, dissatisfied with everything and blaming others for his own limitations. Always looking for an ideal, he became infatuated with one individual or style after another. He was over-dependent on others and foolish about women. He lacked the stamina, dedication and steady commitment he needed to develop fully his considerable and varied gifts. An accomplished pianist, he also studied medicine for a number of years. His association with the Bloomsbury Group was not altogether beneficial. Caught up in their intrigues and complicated personal relationships, his work fluctuated. He fell in love with the formidable literary hostess and patron of the arts, Lady Ottoline Morrell, while still emotionally involved with his first wife, Euphemia, and with Dorelia, the wife of Augustus John. He made a second late marriage and once he had a strong sensible woman to lean on, he tried to obliterate all memory of his unorthodox past and became an established family man and a professional portrait painter.

Henry Lamb was brought up in Manchester, which he detested, in a conventional academic family, whom he rejected. In true Bohemian fashion, he abandoned his medical studies and ran away to London with a sixteen-year-old model, Nina Forrest, whom he renamed Euphemia. They married in 1906 and lived in a precarious and tempestuous partnership for over twenty years, despite the fact that Euphemia had liaisons with Innes and other artists in his circle. From 1904-7, Henry studied in the Chelsea art school, run privately by Augustus John who became the great influence on his work. He visited Paris in 1908 with the John family and studied at L'École de La Palette with Jacques-Emil Blanche. With the New English Art Club, he regularly exhibited well-designed and painted figure compositions. His work was praised by Sickert who said that 'Lamb is not only a great talent but a great talent under the guidance of a clear and educated brain.' On another occasion, however, he warned all the followers of Augustus John that his 'intensity and virtuosity' could not be matched. John's world was so personal to himself, Sickert maintained, that any painter who imitated him was likely to become a 'derivative romantic'.

Lamb's great masterpiece is his portrait of Lytton Strachey. He painted it in 1914 after two years of making studies and drawings deep in the heart of Bloomsbury. It is a superb evocation of the man and his world, intricately designed and wonderfully well painted in a style of austere naturalism. Revealing of Strachey's complex and strange personality, it has a haunting power. Lytton, who was homosexual, fell in love with Lamb. Startlingly handsome and engaging as he was, Lamb was used to such advances and fended him off, and something of the sadness and frustration of Lytton's intense emotional life as well as his

deep introspection comes across. Lamb was never again to paint anything so rare. It shows what an immensely interesting and original artist he might have become if he had developed the strength of personality to match his great gifts.

The Camden Town Group meant very little to him. He lacked the generosity of spirit to give himself to any group and a certain petulance and suspicion made him wary of any involvement with societies. In 1909-11, he had a studio in Fitzroy Street and attended Sickert's regular Saturday 'At Homes'. When Spencer Gore invited him to join the other Camden Towners in setting up the new Group, he responded patronisingly but agreed out of curiosity. He exhibited at their first two

Henry Lamb, *A Gola Islander* (1912)
Charcoal, 11½ × 8½in (29 × 21.5cm). Private collection.

Henry Lamb, *Self-Portrait* (n.d.)
Charcoal, 12 × 8in (30 × 21cm). Ashmolean Museum, Oxford.

WILLIAM RATCLIFFE

William Ratcliffe was tiny – only 4ft 10in, bald and very shy. He had no settled home and flitted from one friend or relative to another, eating mainly cornflakes. All his belongings could be carried in a rucksack and he had a paintbox and a portable easel. It was Harold Gilman who encouraged him to paint when they met in Letchworth in 1908. Ratcliffe was then nearly forty and he seems to have attached himself to Gilman and by extension to the Camden Town Group. He moved to London and enrolled at the Slade School for one term in 1910, attending the Fitzroy Street meetings on Saturday afternoons. Painting became his overriding passion and he did very little else for the rest of his life.

Gilman's influence on Ratcliffe was profound and he supported him emotionally and financially. When they met in Letchworth, Ratcliffe had been working for nearly twenty years as a wallpaper designer. He had studied design at Manchester School of Art under Walter Crane and had probably moved to Letchworth to take up work with one of the printing companies; he certainly produced the artwork for the Garden City calendar and did a series of postcard views which were on sale in 1908. Gilman's forceful and ebullient personality carried him along and he exhibited at the Allied Artists' Association and with the Camden Town Group from 1911. He had little success and was very poor. Gilman's death in 1919 was a devastating blow to him but he continued to paint; in watercolours, probably because he could not afford oils and canvas.

JAMES DICKSON INNES

James Dickson Innes was consumptive. At the age of twenty-one he contracted tuberculosis and his life was dominated by it. He painted in a fever of impatience, always conscious of time running out. His was a romantic lyrical vision, often touched by escapist fantasy; a typical landscape would have the bluest possible sky with rose-coloured peaks and golden clouds. Mountains were his theme and he contemplated them with reverent awe. You feel that his absorption and the mood of exaltation they induced in him is expressed in vivid and original colour. The colour purple had a special significance for him and helps to bring an exotic, sometimes violent element into his work.

He turned to drink to help him to forget the heavy shadow over his life. Augustus John, who was his close friend and drinking-companion, used to go on painting trips with him to the South of France and to Wales which was Innes' birthplace and spiritual home. The mountains of Wales inspired his best work and John wrote a revealing account of an

shows in 1911 but withdrew his support soon afterwards. In fact he was always more comfortable with the Bloomsbury circle of artists and writers. During the First World War he became an official war artist and was awarded an MC. From 1921 he exhibited at the Royal Academy and was elected RA in 1949. He married Lady Pansy Pakenham in 1928 and settled down to a tranquil family life, making his living from portraiture and becoming part of the art establishment he had once despised.

William Ratcliffe, *Still Life on the Kitchen Table* (n.d.)
Oil on canvas, 18 × 14in (46 × 36cm). Private collection.

The Camden Town Group was of little importance in his development. He was a member in name only and joined with Augustus John whom he revered. Neither of them had much in common with the typical Camden Towners and their realism. Nor was their romantic subject matter in keeping with the essentially urban themes of Sickert and his circle. Innes may well have been influenced by the brilliant colour of Gore and Gilman, however, once they had found a personal style. He was a student at the Slade School, as they were, but several years later, from 1905-8. His main influence there was Wilson Steer, whose watercolours he particularly admired. He made a thorough study of the work of Turner and Constable and tried to emulate the clear-cut forms and austere design of Cotman.

The heat and light of the South of France, which he first visited in 1908, released his daring sense of colour. This transforming experience gave him his direction and he applied what he had learned in his vivid depiction of the Welsh mountains. He died at the age of twenty-seven. A romantic lover of life as well as a passionate painter, he looked the part and John has left us a lively portrait of him:

> He himself cut an arresting figure, a Quaker hat, a coloured silk scarf, and a long overcoat set off features of a slightly cadaverous cast, with glittering black eyes, a wide sardonic mouth, a prominent nose and a large bony forehead, invaded by streaks of thin black hair. He carried an ebony cane with a gold top, and spoke with a heavy English accent, which had been imposed on an agreeable Welsh substratum.

AUGUSTUS JOHN

Augustus John had a prodigious talent. He was a superb draughtsman and at the Slade School, where he was a student from 1894 to 1898, his phenomenal mastery of drawing made him a legend. The admiration which John's work evoked is described by Spencer Gore in a letter to Doman Turner in 1909:

> When I went there he was making hundreds of the most elaborate and careful drawings… I have seen sketch-books full of the drawings of people's arms and feet, of guitars and pieces of furniture, copies of old masters, etc. He used at that time to shift his rooms occasionally and people used to go and collect the torn-up scraps on the floor which was always littered with them and piece them together. I know people who got many wonderful drawings in that way.

There was a story behind his extraordinary talent. John was said to be

expedition they made together. It was in the spring of 1911 to the Arenig valley north of Bala. John said that Innes regarded Mount Arenig as his spiritual property and worked feverishly to try to do justice to what he loved:

> At this time Innes' activity was prodigious; he rarely returned of an evening without a couple of panels completed. These were, it is true, rapidly done, but they usually meant long rambles over the moors in search of the magical moment. Perhaps he felt he must hasten while there was time to make these votive offerings to the mountains he loved with religious fervour.

James Dickson Innes, *Aloes* (1910)
Oil on panel, 9 × 13in (22 × 33cm). Private collection.

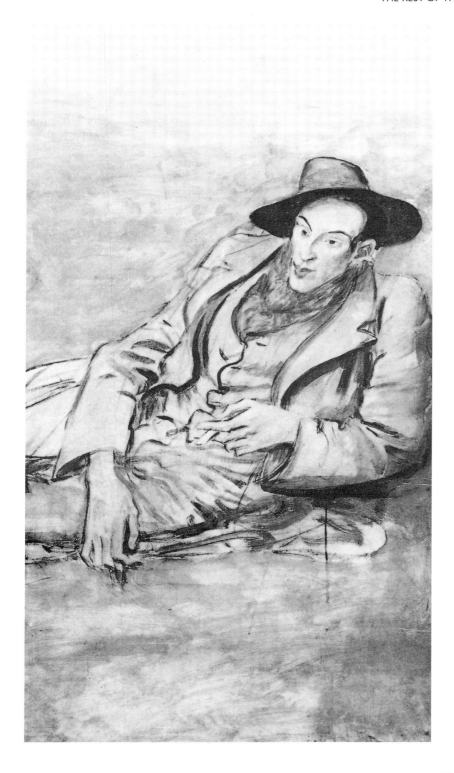

'quiet, methodical and by no means remarkable' when he first went to the Slade. While diving at Tenby, it was said, he struck his head on a rock and emerged from the water 'a genius'. John's friends delighted in telling this tale because it was so in keeping with his fabulous personality. It pleased him that something colourful should emerge from the grey place he detested. He and his equally gifted sister Gwen loathed the narrow parochialism of their home town and planned their escape from the 'frantic boredom' they endured there. They shared a passion for personal liberty and in their different ways lived wholly unconventional, unfettered lives.

Although he drew like a master, John's painting was uneven and was most successful when it was linear. Strong contours, a flowing sensitive line, boldness and spontaneity characterise his finest pictures. When the subject really interested him, he could carry all before him in a first impetuous attack and turn out masterpieces almost without effort. His approach was imaginative and intuitive and depended on strong emotion; planning and the slow building-up of a composition had no appeal for him. He found his models among gypsies, tramps and vagrants, seeking out strange characters who lived nomadic lives outside society. At the Slade School he would haunt the street markets for unusual characters and during summer holidays he used to paint what was most primitive and wild in the landscape and among the people of Wales. He was driven by a longing for a free, abundant and romantic life and he idealised nomads: 'The absolute isolation of the gypsies seemed to me the rarest and most unattainable thing in the world', he wrote.

He painted the visible world. Every one of his paintings and drawings testifies to his passionate and sensuous response to nature. His life was a saga and his work was an extension of himself. He painted those people who attracted or interested him and his landscapes are of places where he enjoyed living. Wyndham Lewis wrote that:

> Nature is for him like a tremendous carnival in the midst of which he finds himself. But there is nothing of the spectator about Mr John. He is very much part of the saturnalia. It is only because he enjoys it so much that he is moved to report upon it – in a fever of optical emotion, before the selected object passes on and is lost in the crowd.

He became the most notable British painter of his generation, making after the First World War, an international reputation as a portrait painter of exceptional power and skill. Beauty of every kind moved him; he painted flowers, children, small figures in a romantic setting, pure landscape and still lifes. He liked best to work on a large scale and his most ambitious works were big decorative canvases on the theme of

Augustus John, *Portrait of J. D. Innes, reclining with a cigarette* (n.d.)
Gouache on paper mounted on linen, 57 × 27½in (145 × 70cm).
National Museum of Wales, Cardiff.

wandering gypsies in ideal lands. What was wild, strong or noble in the faces of men inspired him and he could convey character with ease and bravura. Sensual and passionate, he was libertine and gloried in his 'instinctive relationship' with women. His most famous model was his second wife, Dorelia McNeill. He had many children and drew and painted them with matchless truth, bringing out their vulnerability. His studies of women are often less convincing because he failed to understand them or to relate to them as individuals. He painted them as types to suit his vision, idealising and depersonalising them.

As a young man, John became friends with James Dickson Innes, a painter with an original and lyrical vision. Innes had a passion for mountains – those of his native Wales in particular. His intense and romantic vision of mountain scenery was an inspiration to John who emulated and enhanced it. John's personal interpretation was of sketchily painted figures in brilliant and evocative mountain settings. What is remarkable and poetic is the way John conveys the harmony between the figures and the landscape. Pure colour in a high key and a strange, still atmosphere make these pictures quite compelling.

The Camden Town Group was not of major importance to John's development. He exhibited only two pictures – both landscapes of Welsh subjects in the exhibition of 1911. As the hero of the Slade School he was taken up immediately by the Carfax Gallery, and was elected to the New English Art Club in 1903 and became a Royal Academician in 1938. Sought after and lionised, his Bohemian way of life – extensive travelling with his huge family, often in a Romany caravan – made him into a living legend. He served as an official war artist during the First World War and was awarded the OM in 1941. During the last decades of his life, John's reputation as a wild notorious Bohemian began to overshadow his achievements as a great artist. John Rothenstein, who knew him and admired his work, regarded him as a genius and said that: 'In his inspired moments no living British painter so nearly approached the grandeur and radiance of vision, the understanding of the human drama, or the power of hand and eye of the great masters of the past.'

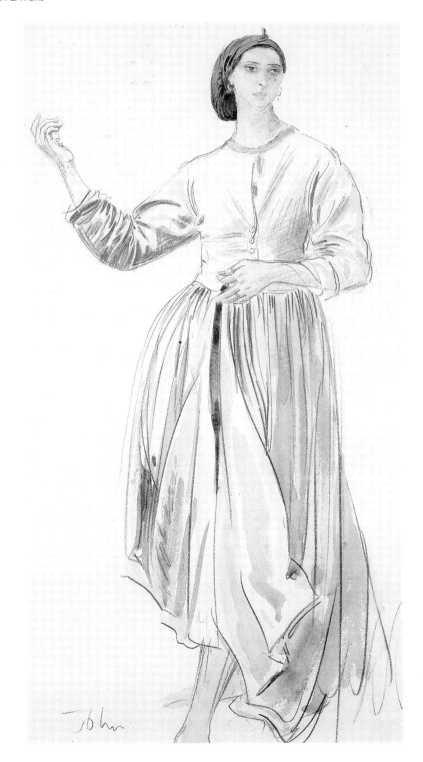

Augustus John, *Dorelia Standing* (n.d.)
Watercolour and pencil, 21 × 11in (53 × 28cm). Private collection.

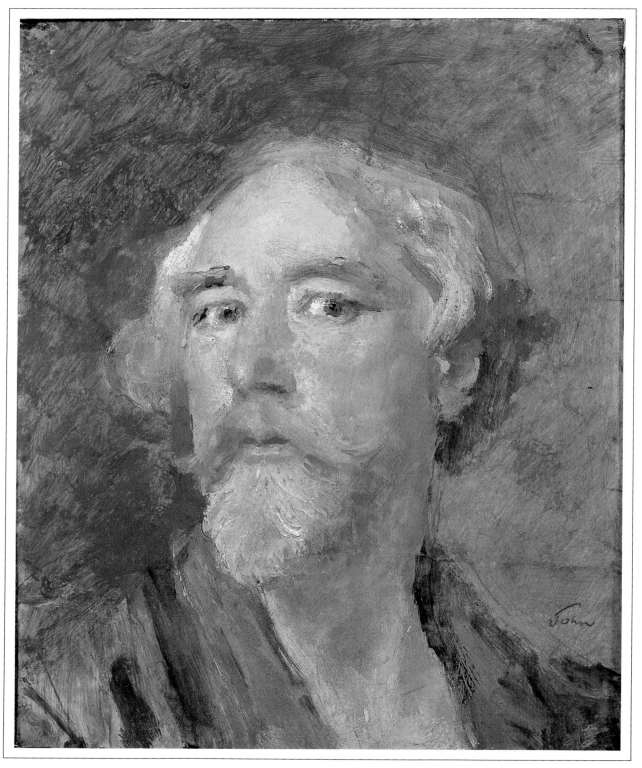

FURTHER READING

Baron, Wendy. *Sickert* (London, 1973).

Baron, Wendy. *The Camden Town Group* (London, 1979).

Browse, Lilian. *Sickert* (London, 1960).

Lilly, Marjorie. *Sickert, The Painter and his Circle* (London 1971).

Rothenstein, John. 'Sickert to Lowry', *Modern English Painters* vol. 1 (London, 1952).

Sitwell, Osbert, ed. *A Free House – Being the Writings of W.R. Sickert* (London, 1947).

Sutton, Denys. *Walter Sickert* (London, 1976).

Robert Bevan, *Horse Sale at the Barbican* (1919)
Oil on canvas, 31 × 48in (77 × 120cm). Tate Gallery.

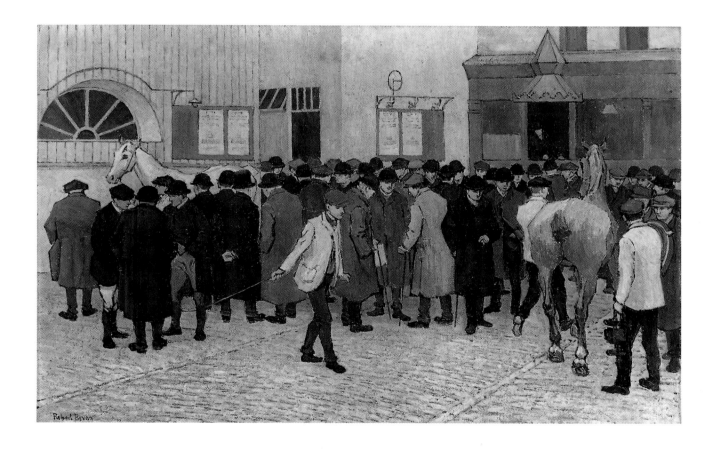

(Opposite)
Augustus John, *Self-Portrait* (n.d.)
Oil on panel, 10 × 8in (26 × 20cm). Private collection.

INDEX

NOTE: A page number in **bold type** indicates an illustration.